IMAGES OF AMERICAN INDIAN ART

BY JOZEFA STUART
AND ROBERT H. ASHTON, JR.

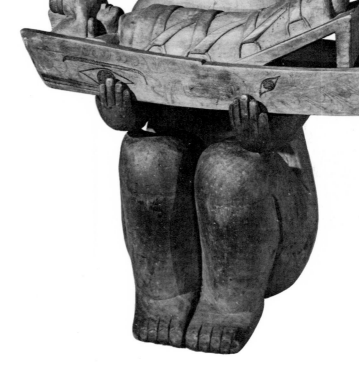

A WALKER GALLERY BOOK

WALKER AND COMPANY • 720 FIFTH AVENUE • NEW YORK, NEW YORK 10019

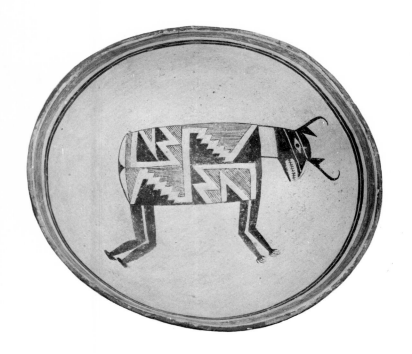

STAFF

EDITORIAL DIRECTOR: Richard K. Winslow

ART DIRECTOR: Barbara Huntley

MANAGING EDITOR: Andrea H. Curley

RESEARCH: Mary Jane Hodges
Judith Szarka

PRODUCTION: David Kellogg

FRONT COVER: A three-tiered mask from the Kwakuitl tribe of British Columbia.
Courtesy, the Museum of the American Indian, Heye Foundation, New York, photograph by Carmelo Guadagno

BACK COVER: A Kwakuitl mask of British Columbia representing the Sun.
Courtesy, the Collection of Dr. and Mrs. Jerry Solin

OVERLEAF: A mother holds her bundled child in this woodcarving from the Nootka tribe of British Columbia.
Courtesy, the Museum of the American Indian, Heye Foundation, New York

ABOVE: An antelope decorates a prehistoric red and white bowl from the Mimbres Valley of New Mexico.
Courtesy, the Museum of the American Indian, Heye Foundation, New York

OPPOSITE: A wooden horse painted by a Sioux of the Plains Indians.
Courtesy, the Robinson Museum, Pierre, South Dakota

First published in the United States of America in 1977 by the Walker Publishing Company, Inc.

Published simultaneously in Canada by Beaverbooks, Limited, Pickering, Ontario

Printed in Japan by Dai Nippon Printing Co., Ltd., Tokyo

Cloth ISBN: 0-8027-0577-4
Paper ISBN: 0-8027-7116-5
Library of Congress Catalog Card Number: 77-78131

10 9 8 7 6 5 4 3 2 1

Introduction

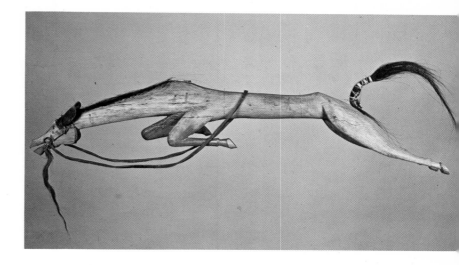

To General George Armstrong Custer, the American Indian seemed to be a road to personal glory. To Hollywood, the "Injun" meant dollar signs. To waves of European immigrants over the past four centuries, the Indians were simply in the way, to be put off and pushed aside.

With very few exceptions, the Indian's art and art forms were treated in much the same manner. Early explorers and traders took a few samples back to Europe; the great masks of the Northwest Indians were prized for a time by the czars and other European royalty. But until no more than ten years ago, Indian art was generally regarded a curiosity, a novelty, or an interesting avenue of study for the ethnographer and archaeologist, but scarcely anything a reputable art museum would display under the same roof with its Renaissance masters.

We now know that the American Indian's art forms have been at least ten thousand years in the making. It was that long ago, probably ten thousand years earlier, that man arrived on the North American continent from Asia. At first, the Indian lived a life of hunting and gathering, roaming the land to take what it offered. Some two thousand years ago, life became more settled; the Indian's skills in fashioning tools and weapons, baskets and bowls, shelter and clothing became more varied and elaborate. As agriculture flourished, there was time for more than survival—for embellishment of the useful implements of everyday life, and for celebrations and stylized appeals to supernatural powers.

What the Indian expressed in this emerging art is often labelled "primitive." But its motifs can just as readily remind us of aspects of modern abstract art; at the same time Indian art can evoke much of the same aesthetic response that one feels in the art of Western antiquity, in the art of the Celts, or the Scythians, or the ancient Greeks.

I prefer to avoid the question of rigid categorization of Indian art, for it is actually a whole universe of creation spread over thousands of years and hundreds of cultures each evolving along its own pathways at different rates—and still evolving today. Instead, let us say that American Indian art is a kind of graphic literature, for these cultures had little or no written language as we know it.

Ralph T. Coe, director of the William Rockhill Nelson Gallery of Art—Atkins Museum of Fine Arts in Kansas City put it well :

> American Indian art gives visual expression and embodiment to the mores of Indian cultures. It is as simple as that—and as complex—for this simplicity is compounded by a union of aesthetics and craftsmanship, both perceived as non-distinct from one another. Since these two concepts are not differentiated traditionally in the Indian world (as they are in the white world), artistic materials are at once de-materialized into a kind of literature of the people. Indian art is made a literate thing by people who think in symbols. Indians created "art" long before there was any such term; this is to their credit and emphasizes the naturalness of their attitudes toward creativity.

Take, for example, the magnificent horse shown above and in color on page 49. Almost three feet in length, it was carved in wood some eighty to one hundred years ago by an unknown Sioux Indian. Soon after horses had been introduced by Europeans, they became essential to the Sioux' nomadic life, furnishing a very practical balance between life and death in battle and, symbolically, a potent sign of power and prestige. Today, this Sioux carving has the power to make us feel the stillness and timelessness of the Great Plains in the days before highways and shopping plazas. It is unquestionably art of the highest order and, to my mind, one of the great sculptures of all time.

What the horse meant to the Sioux could have an entirely different meaning to another people a few hundred miles away. One often hears the remark that a certain symbol or motif represents "Indian design." Actually, one can no more refer to a design than one could talk about a European design or an Asian design. Across the width and breadth of North America the evolving tribes were often as separated by their languages and religions and art as they were physically separated by great rivers and mountain ranges. .

And yet there are unmistakable similarities—symbols and motifs that show up again and again. Even so it is important to remember that these symbols, so alike in the white man's eyes, carried quite separate meaning for each artist, each tribe.

Several years ago I was in the shop of Tom Bahti in Tucson, Arizona. On the wall was a poster showing rows of Indian symbols, with a definition beside each one. For example, crossed arrows meant war, crossed hands meant friendship, cloud symbols meant rain, and so on. At the bottom of the poster Tom Bahti himself had sketched a drawing of a loaf of bologna with the notation, "Synonymous with all of the above."

Now, having stated a case for symbolism and its diversity, I am going to pull out the rug and point out that patterns in Indian art are frequently not symbolic at all; they are nothing but pure design. A prehistoric pot from the American Southwest can bear simple geometric designs divided only by space. There is no meaning; the potter appears to have decorated the piece for the sheer joy of it. A Navajo textile, such as a first-phase chief's blanket, is no more than a series of alternating stripes, pleasing to the eye, but hardly leading to any degrees of significance. Crow beadwork of the Northern Plains, a basket of the White Mountain Apache, a bag made of corn husk from the Nez Perce of the Northwest . . . and many more are examples of pure design adorning useful objects for the sake of making them more appealing.

There are Indian artists today who work with the same definition and the same sensitivity and the same aesthetic vitality as their ancestors. Fritz Scholder, the painter; Charles Loloma, jeweler; Larry Golsh, jeweler and painter; and Maria Martinez, the well-know Pueblo potter of San Ildefonso, are among just a few from the Southwest who are continuing in this spirit. Their work often raises the question: Is it traditional? Does it maintain the integrity of American Indian art?

A few years ago I was judging jewelry entries at the Indian Market in Santa Fe, New Mexico. One artist had entered a silver concha belt which was considered to be modern. I had seen nothing like it before, and no one else seemed to know anything about this particular belt or its creator other than that he was of Indian ancestry. Its design was not at all what one would think of as "Indian," nor was it representative of what we consider to be Indian culture. Yet, it had been created by an American Indian artist, the workmanship was superb, and, based on that, I gave this belt the first award. Second prize was awarded to a "traditional" belt from the Zuñi Pueblo which was so-called "needlepoint" pattern with hundreds of pieces of small turquoise stones arranged in a sunburst design set in conchas of silver. At that point I was criticized by a well-known expert for honoring a "modern" design over one that was "traditional." He pointed out that if we were to keep tradition alive we had to give first prizes to traditional artists. My reply was that the Zuñi belt has been "traditional" for only fifty or sixty years. In 1890, if there had been such a thing as an Indian art show and someone had entered this Zuñi belt, it would have been considered "modern" and non-traditional, and perhaps some expert at that time would have criticized the judge for awarding it first prize.

The excitement in American Indian art is that it is always moving forward. Today's artists are reaching out for new expressions based both on their own personal tribal background and imaginative adaptations of alien cultures. The Navajos were profoundly influenced by the Pueblos in the seventeenth and eighteenth centuries, and various Plains tribes assimilated each other's culture even as they conquered and, in some cases, destroyed each other. Much of the best contemporary Indian art has adapted European techniques and media—silverworking for jewelry, unravelled factory-made fabrics for rugs and blankets, canvas for painting—without loss of vitality and integrity.

I prefer to think of Indian art, if it must be classified at all, as what might be called Classic Art. It has bridged the centuries. The early pieces look as fresh now as they did when they were created, and the artists working today . . . in jewelry, in pottery, on canvas . . . proudly draw on the past as they look to the future. Indian art is timeless, and the Indian's art, his life, environment, and his history are indivisible.

—ROBERT H. ASHTON, JR.

THIS CEREMONIAL headgear, (opposite) known as a tableta, was worn by kachinas during Pueblo dances. This example dates from the 1880s.

Courtesy, American Indian Art Magazine, photograph by Jerry Jacka

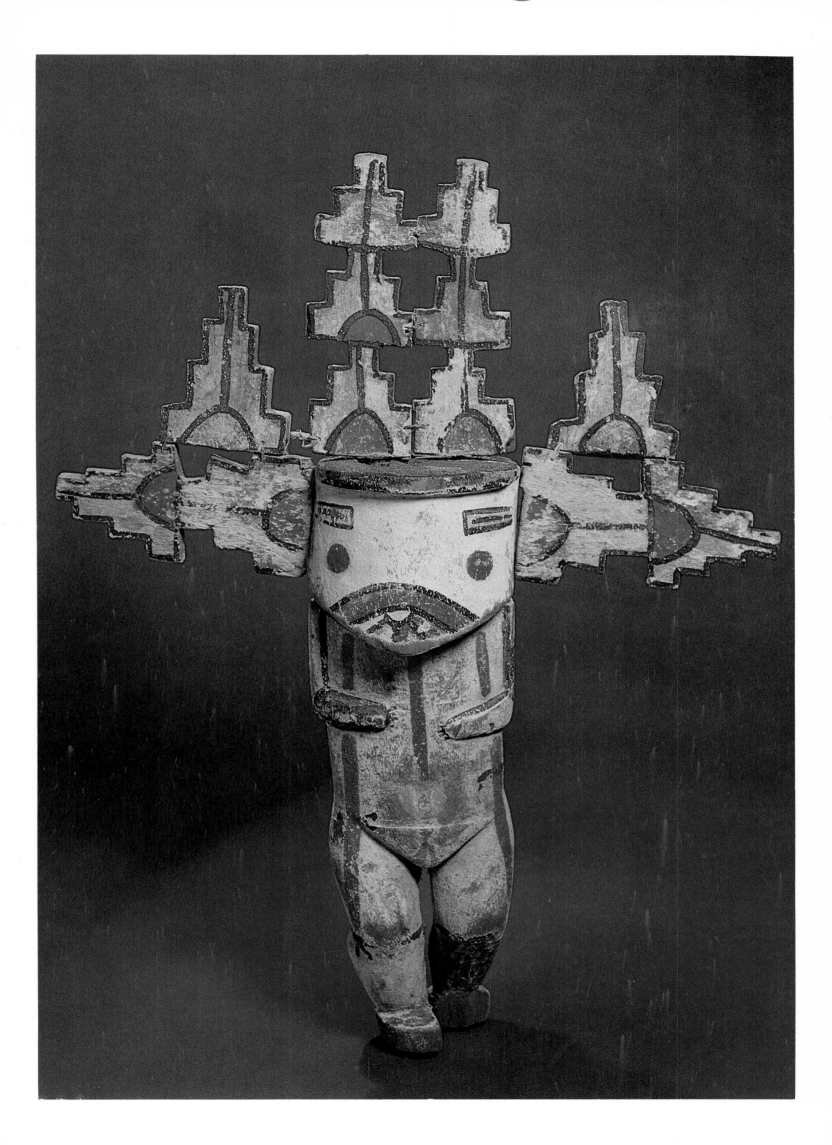

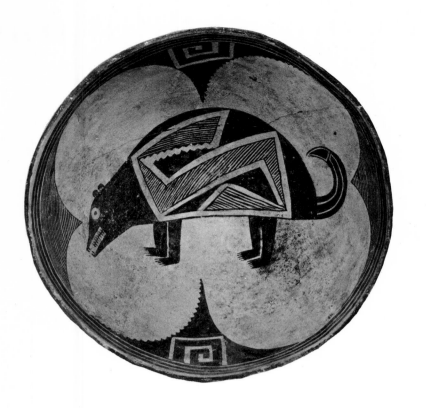

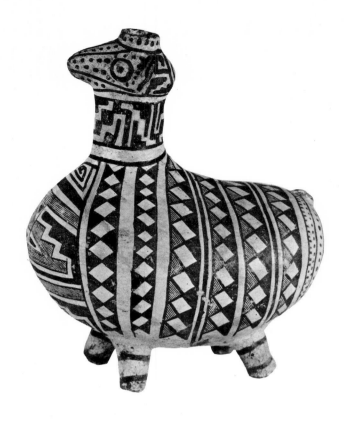

Pottery with a Rich Past

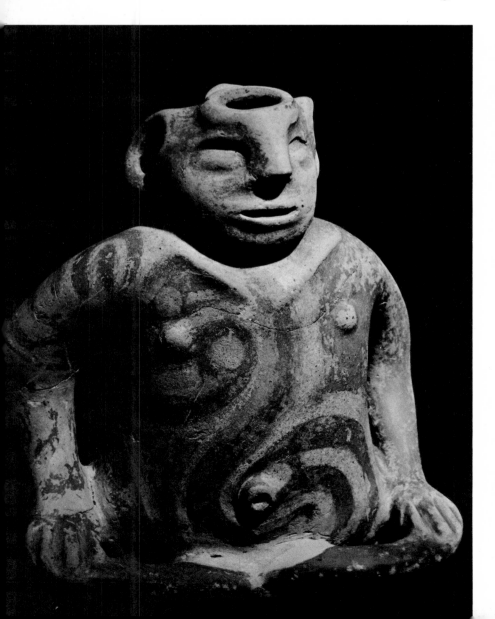

CENTURIES BEFORE Europeans came to America, Indians formed and molded clay by hand, working without a potter's wheel. Geometric patterns, often stylized interpretations of animals, decorate the pottery. The thirteenth-century bowl (*left, top*) adorned with a bear, was found in the Mimbres Valley, New Mexico. The four-footed bird (*above*), also thirteenth-century, comes from the Anasazi culture, forerunner of today's southwest Pueblo Indians. An abstraction of a human face rims a Pueblo bowl of the same period (*opposite, top right*). From Arkansas come both the head-shaped effigy jar (*opposite, center*) and the painted figure (*left*). The humped-back man (*opposite, right*) is one thousand years old.

LEFT, TOP: Courtesy, the Museum of the American Indian, Heye Foundation, New York, photograph by Carmelo Guadagno

ABOVE: Courtesy, the Museum of the American Indian, Heye Foundation, New York, photograph by Carmelo Guadagno

OPPOSITE, FAR RIGHT: Photograph by Jerry Jacka

OPPOSITE, CENTER: Courtesy, the Museum of the American Indian. Heye Foundation, New York

OPPOSITE, RIGHT: Photograph by Jerry Jacka

LEFT: Courtesy, the Museum of the American Indian. Heye Foundation, New York

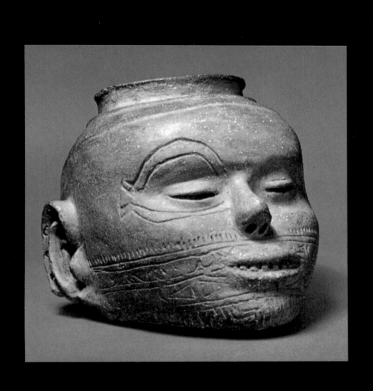

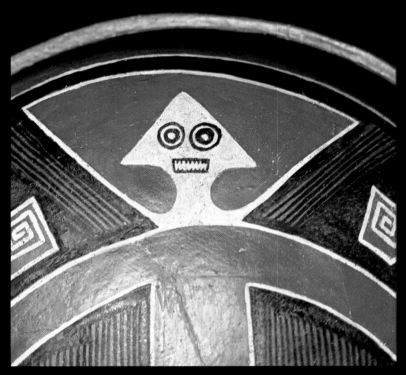

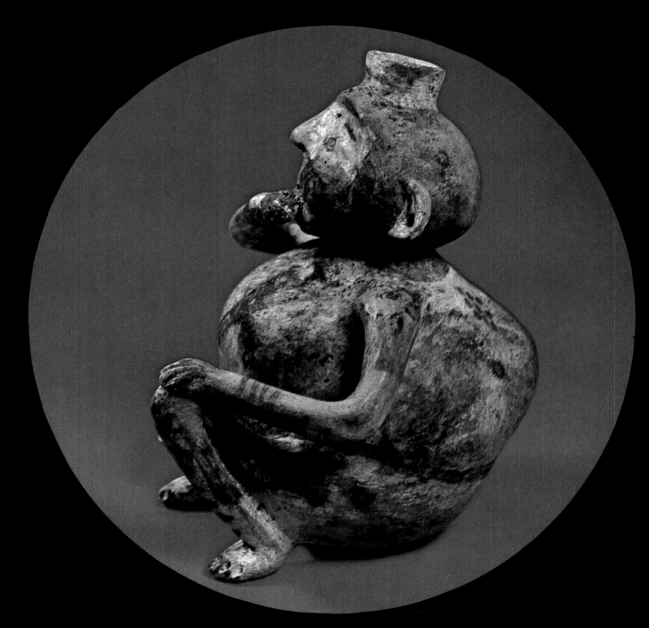

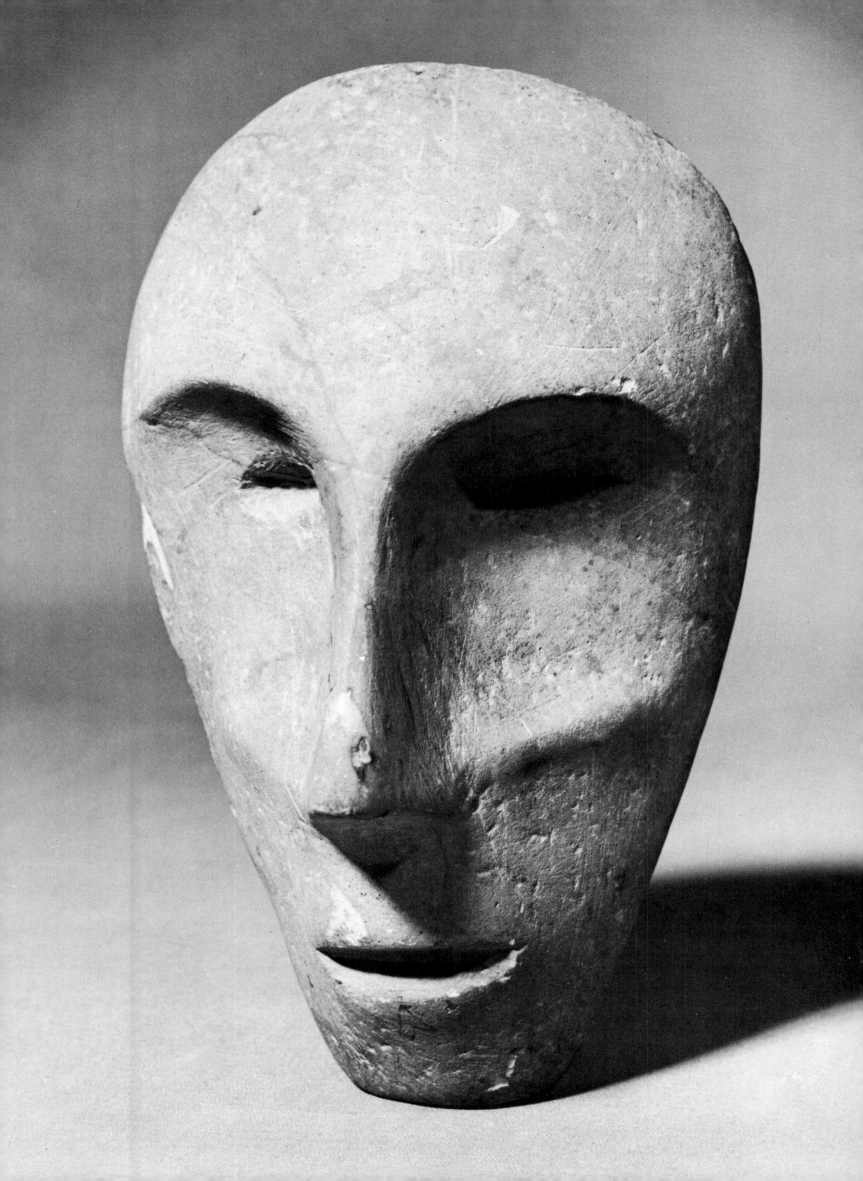

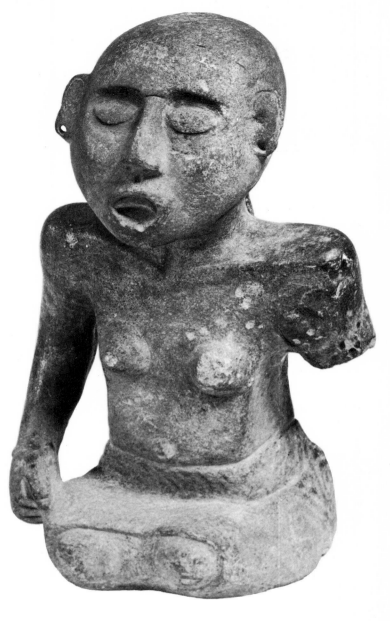

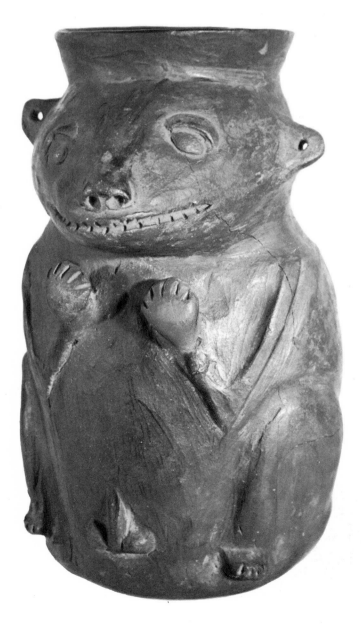

FROM EARTH MOUNDS, which are found from Canada to the Gulf of Mexico, from Virginia to Oklahoma, come tantalizing traces, in stone and clay, of this continent's first inhabitants. These mounds, which could reach sixty feet and measure fourteen hundred in length, began, it is thought, as simple graves and developed into complex ceremonial centers. They were still being built when the Spaniard de Soto explored the Gulf of Mexico in 1540. It was once believed—somewhat romantically—that the mound builders were a long-vanished people but, in fact, they were constructed by ancestors of today's Indian. The face of stone (*opposite*) is eight hundred years old and was found in Kentucky. From a Georgia mound comes the stone figure of a kneeling woman (*above*), once adorned with earrings, and the effigy jar (*left*) portrays a squirrel, to be expected of a people living in the vast woodlands of Mississippi.

ALL PHOTOGRAPHS: Courtesy, the Museum of the American Indian, Heye Foundation, New York

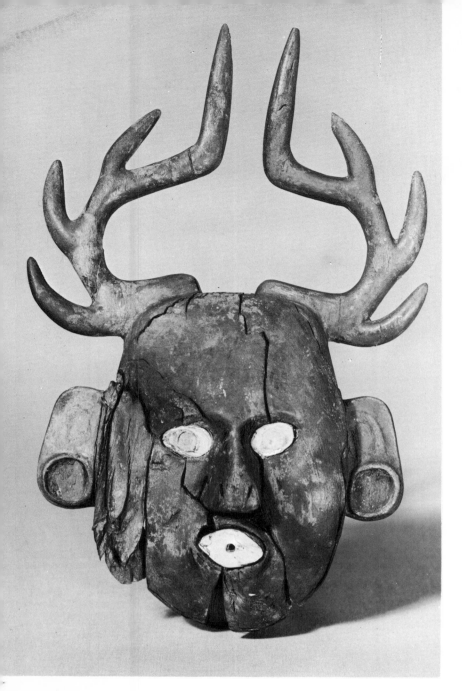

The Mask—
Spiritual Face
of the
Enduring Indian

THE RITUALISTIC USE of masks in ceremonies is as old and as universal as tribal life itself. The wooden mask (*above*) represents a deer with inlaid shells for eyes and mouth. It was found in an Oklahoma archaeological site and has survived for four hundred years. The wooden mask (*right*) is modern and was made by the Cherokees of North Carolina. It portrays a member of the tribe. From Canada's Tsimshian tribe comes a painted mask personifying the Spirit of the Wind (*opposite*).

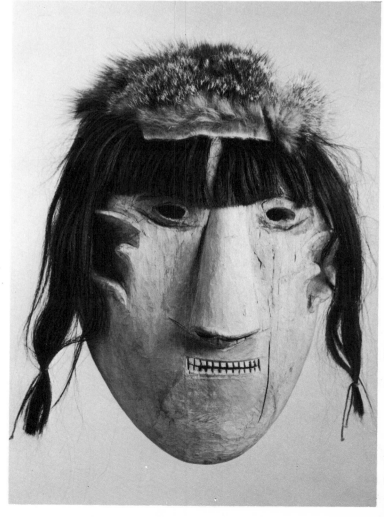

ALL PICTURES: Courtesy, the Museum of the American Indian, Heye Foundation, New York, photograph by Carmelo Guadagno

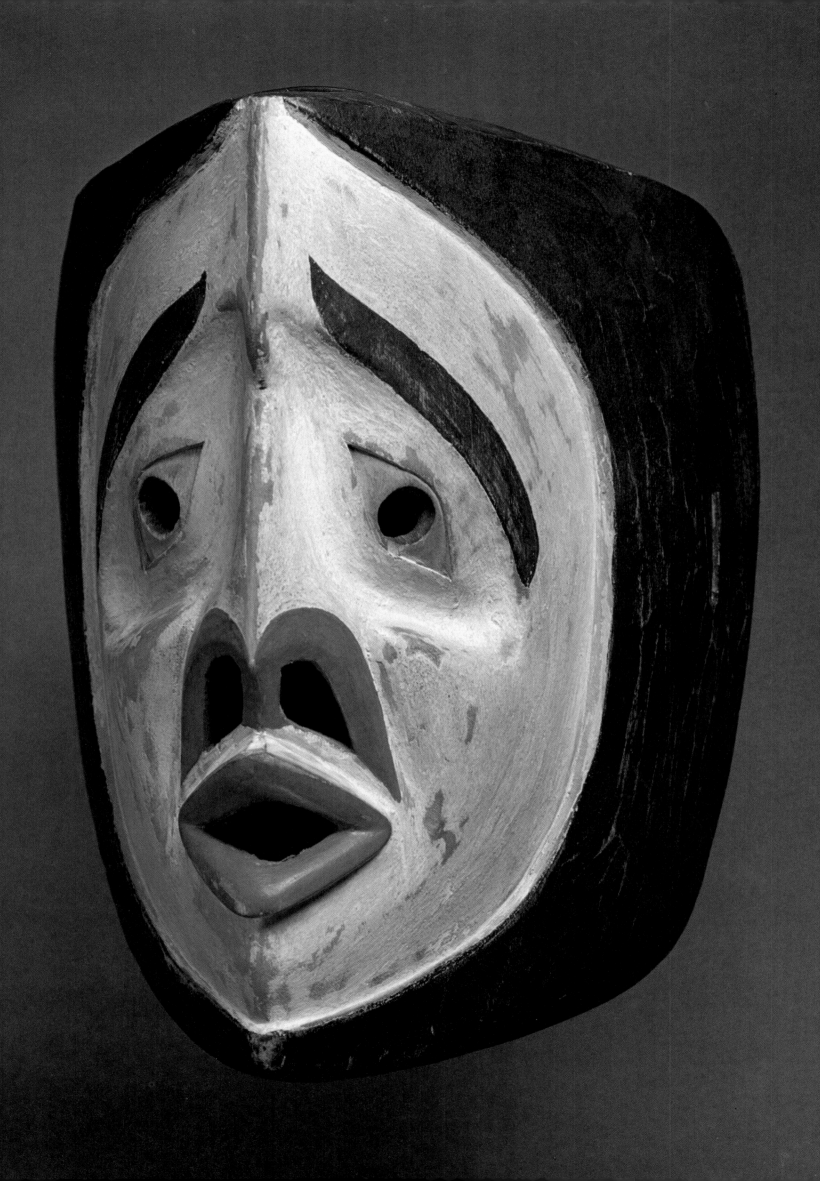

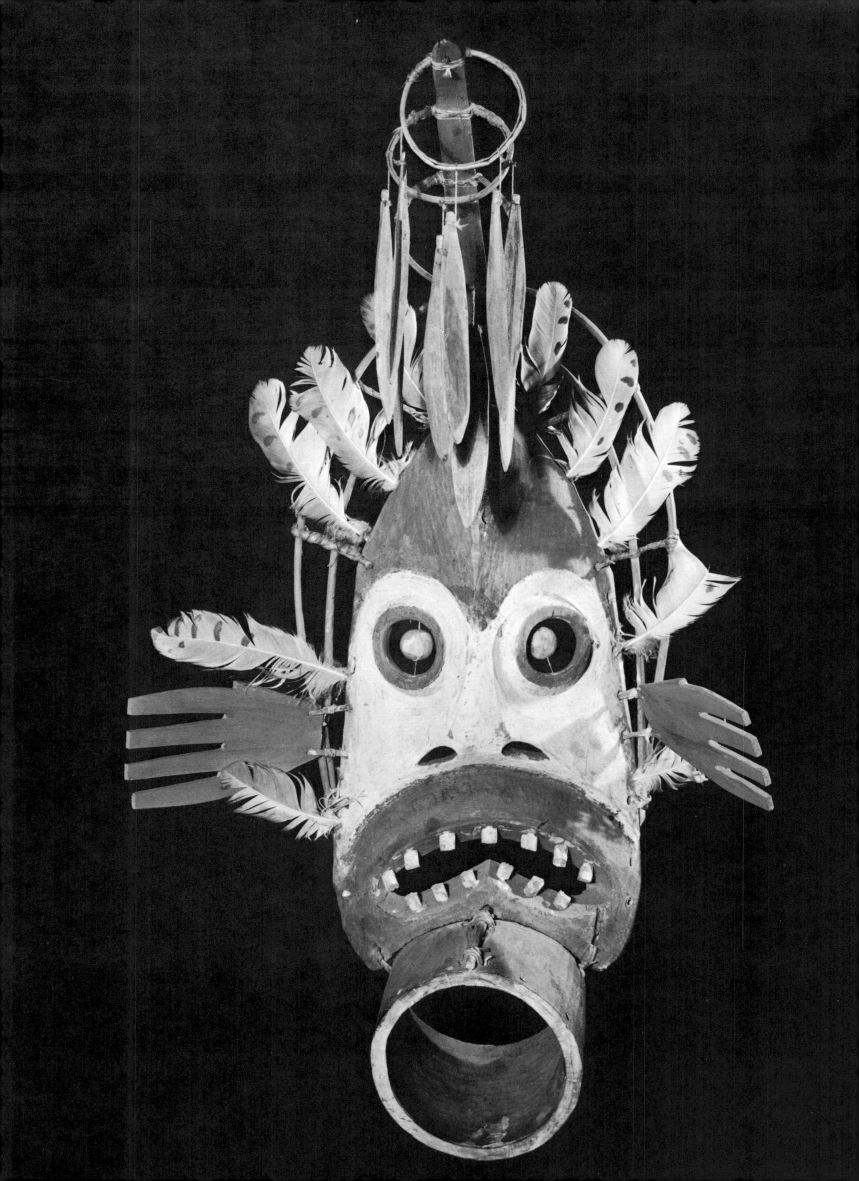

OF ALL THE ART created by Eskimos, none is as highly regarded by connoisseurs as the mask. Almost all masks are intended to be worn during the special dances of religious ceremonies. Often they personify a spirit, as seen in the ornately decorated wooden mask (*opposite*) from Alaska, which represents the Spirit of Cold Weather. The Eskimo mask (*below, left*) was stained red before it was placed near a grave—a memorial to the dead. Shamans, tribal priests, have their own distinctive masks: the one shown here (*below, right*) has a white face, red lips, and ears, left unpainted, which are adorned with string pendants.

The sacred False Face masks of the Senecas of the East Coast (*right*) are rich symbols of a great tradition—they are still made and worn in ceremonies throughout the year.

BELOW, LEFT AND RIGHT: Courtesy, Collection of the Newark Museum, New Jersey
OPPOSITE: Courtesy, the Museum of the American Indian, Heye Foundation, New York, photograph by Carmelo Guadagno.
RIGHT: Courtesy, the Museum of the American Indian, Heye Foundation, New York, photograph by Carmelo Guadagno

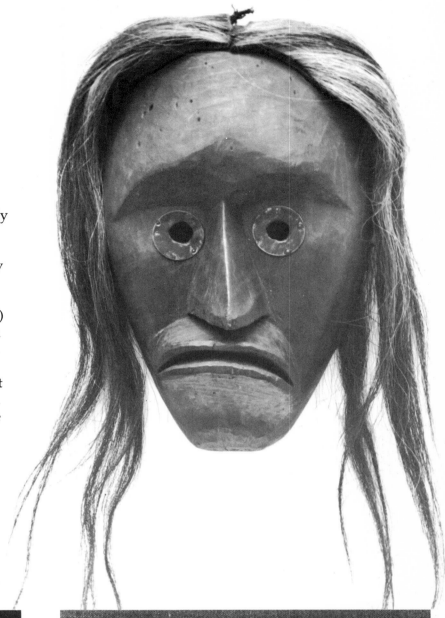

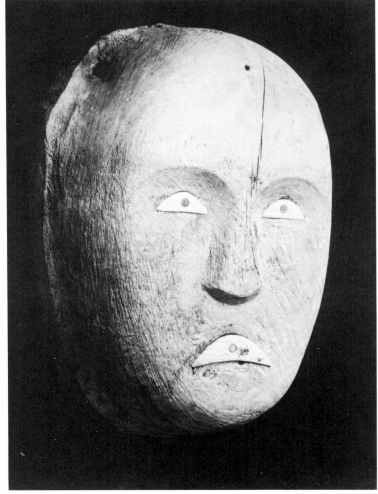

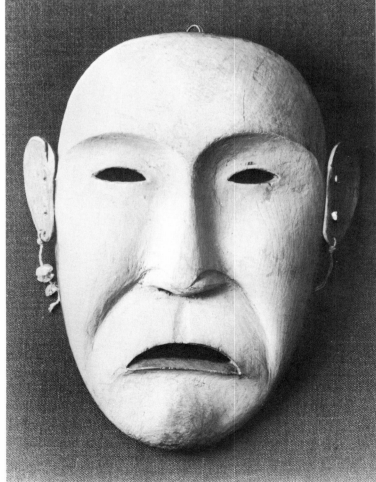

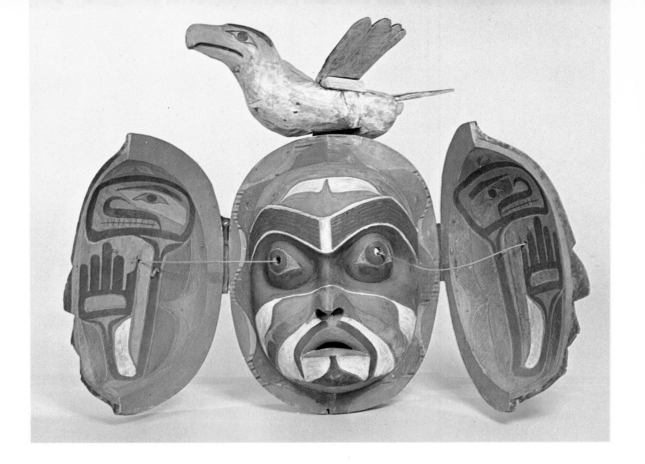

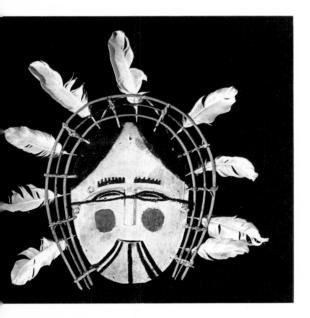

THE MASKS OF the Northwest tribes are proud in appearance and bold in execution. They are carved from abundant native wood and painted with vivid colors. The arts of the Northwest flourished during the nineteenth-century, when trade with Europeans brought wealth to the Indians. The mask of British Columbia's Kwakuitl tribe shown here (*opposite*) dates from the 1890s. The Kwakuitls often incorporated mechanical devices into their masks. Certain masks (*above*) were made with movable sides, which, when closed, became a three-dimensional man's face. When open, such a mask became a dramatic new face. Usually worn by Shamans during dances, the mask's sides could be manipulated by strings. The bird perched on this mask's head is probably the crest of a particular clan.

The Eskimo mask portraying a woman's face (*left*) is prized for its unusually delicate rendering.

The Seneca False Face mask (*below, left*) belongs to a Society dedicated to healing the sick.

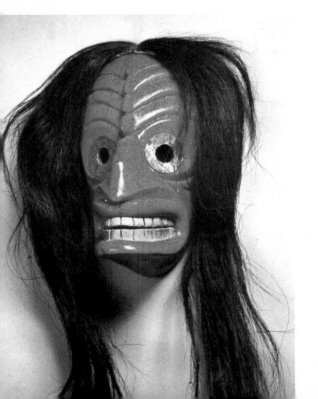

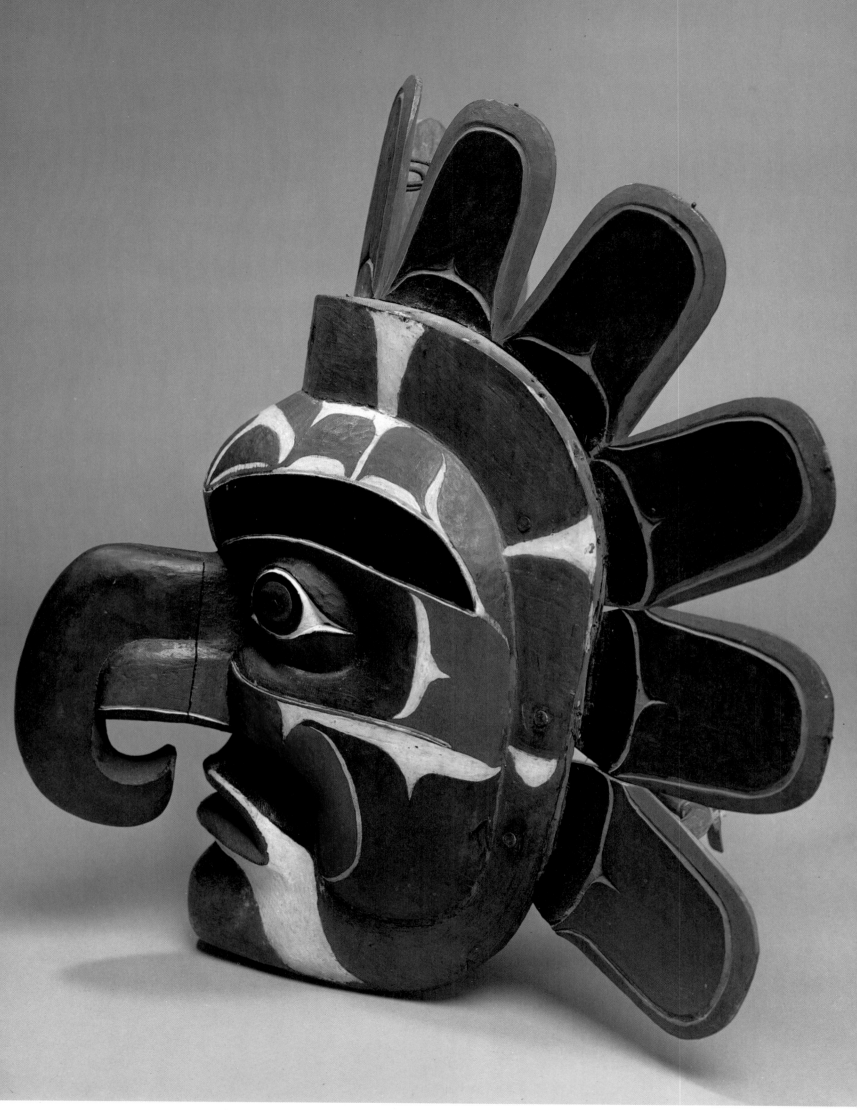

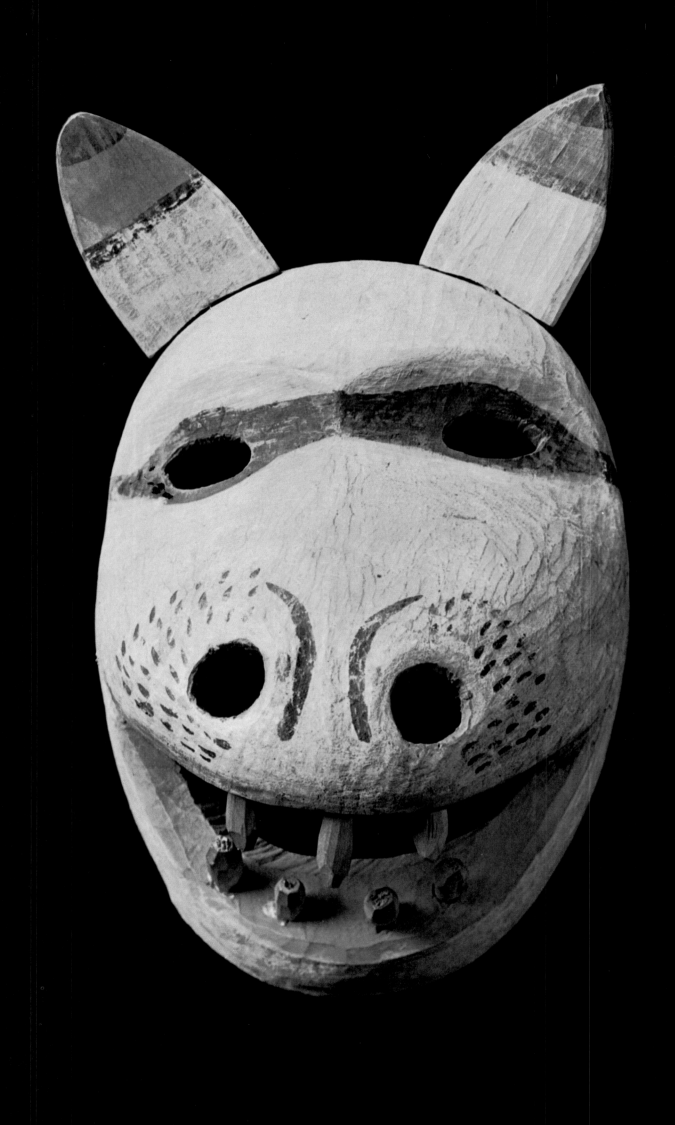

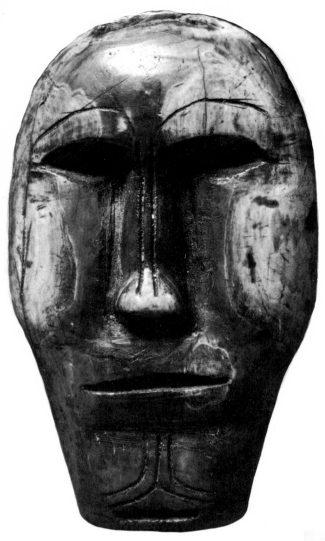

On the Edge of Chance

IN THE PRECARIOUS existence of primitive people, religion, by propitiating the unknown, is a way of ensuring survival. Ceremony and ritual call upon the forces of nature to bring rain to the farmer and deer to the hunter. In the far north, the Eskimo imbues his world with an all-pervasive soul, the *inua*, an attribute of objects, animals and people alike. The intermediary of the physical world and the supernatural is the shaman, controller of spirits and performer of magic. The thousand-year old Eskimo maskette (*left*) was probably part of a shaman's equipment. The contempory Eskimo wolf mask (*opposite*) represents success in hunting. In the arid lands of the south, rain was the life-giving gift of nature. The cloth mask (*below*) is that of the endearing clown spirit—*koyemsi*—of Hopi ritual.

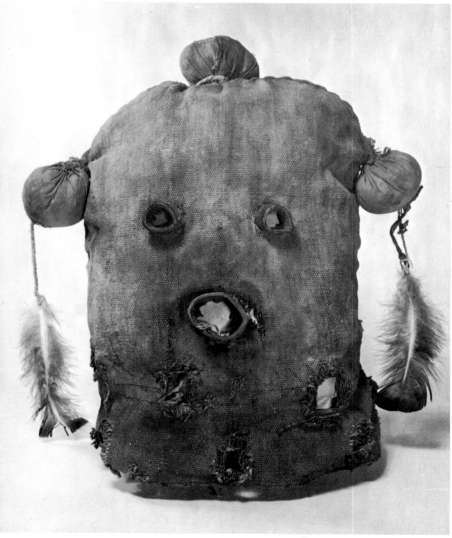

OPPOSITE: Courtesy, the Newark Museum, Newark, New Jersey

ABOVE: Courtesy, Collection of Jonathan and Philip Helstein, New York, photograph by Justin Kerr

RIGHT: Courtesy, the Museum of the American Indian, Heye Foundation, New York, photograph by Carmelo Guadagno

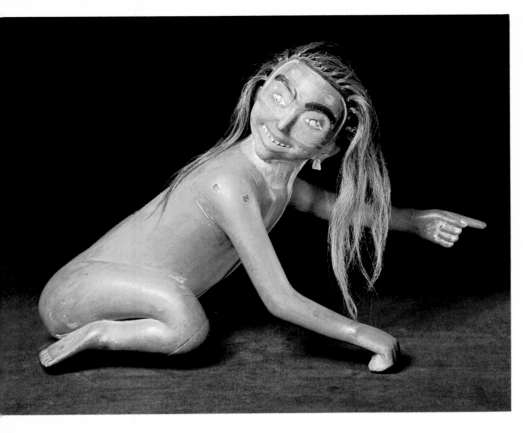

THE INDIAN has never separated his art from his daily life; at the same time he has imbued his art with his religious beliefs, tribal myths and legends. The red figure (*left*) was once the prow of a canoe. It depicts the powerful Land Otter Man, who in the mythology of the Alaskan Tlingits, guides a canoe to safety. The nineteenth-century Eskimo whalebone carving (*below*) portrays five men in an *umiak*. Only five inches long, the carving may have been a good luck charm. The wooden helmet (*opposite*) is an abstract rendering of a bear's face. Alaskan Indians wear such helmets during ritual dances.

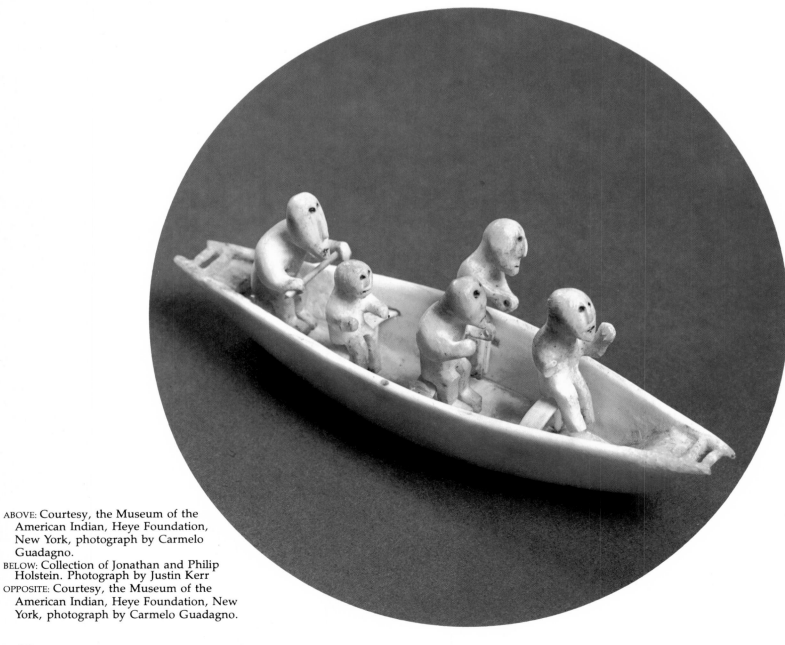

ABOVE: Courtesy, the Museum of the American Indian, Heye Foundation, New York, photograph by Carmelo Guadagno.

BELOW: Collection of Jonathan and Philip Holstein. Photograph by Justin Kerr

OPPOSITE: Courtesy, the Museum of the American Indian, Heye Foundation, New York, photograph by Carmelo Guadagno.

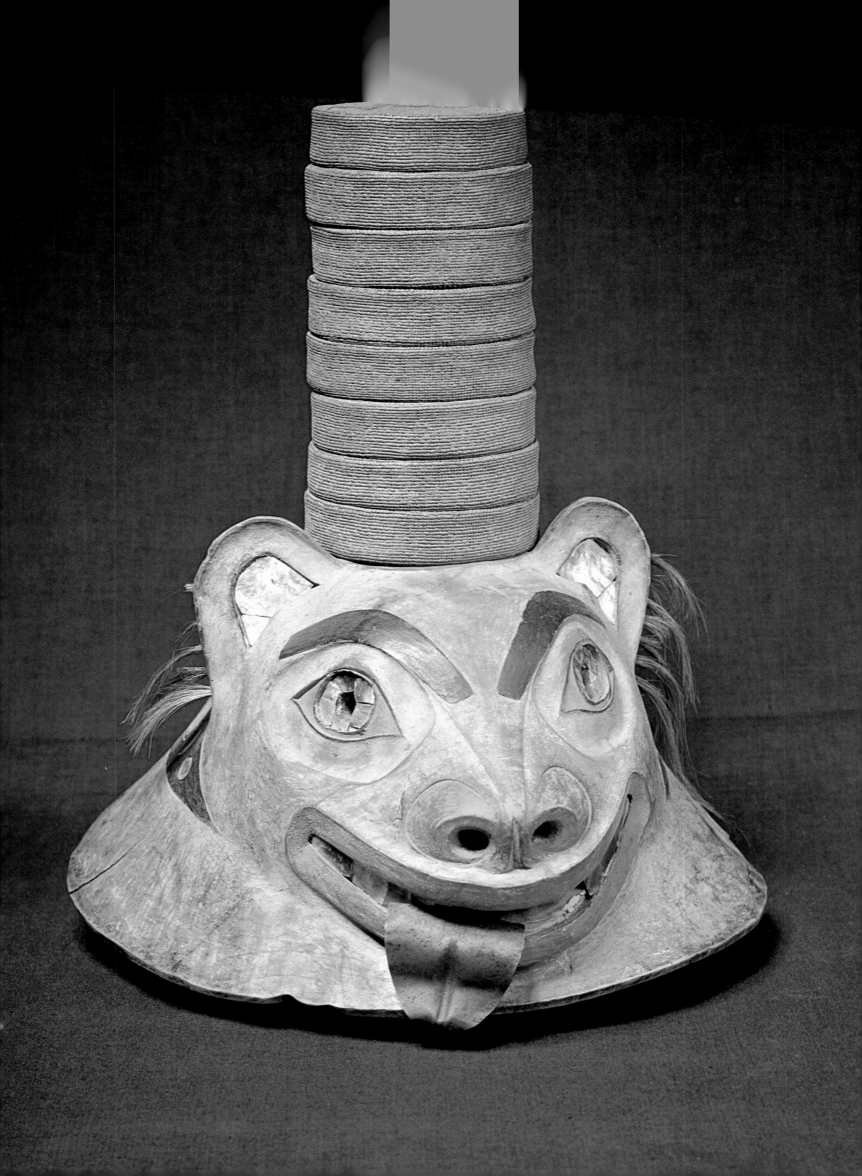

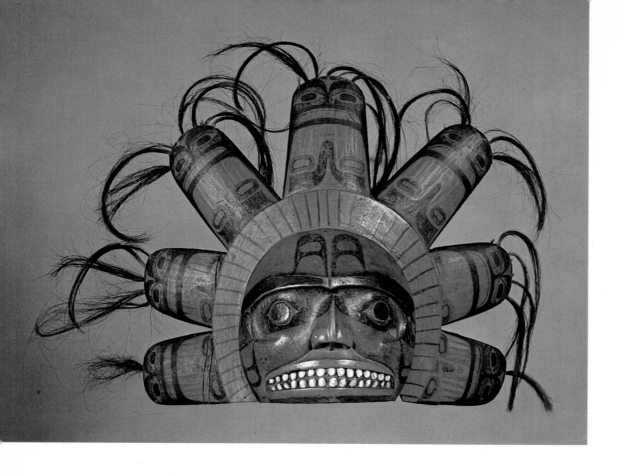

THE NORTHWEST INDIAN, living in a narrow strip of land along the Pacific Coast from Alaska to northern California, took his food from the sea. Its abundance left him time to decorate and ornament his carvings,—most of which have a significance based on mythology—with a wealth of detail. The red headress (*above*) represents the sun, its rays painted with symbolic renderings of the human face. The hair, too, is human. The carved wooden helmet (*below*) with its hawk beak is profusely painted, and each circular disk on top of the helmet represents a potlatch, a gift-giving ceremony undertaken to enhance social prestige. The soaring canoe prow (*opposite*) symbolizes an eagle.

ABOVE: Courtesy, the Museum of the American Indian, Heye Foundation, New York, photograph by Carmelo Guadagno

RIGHT: Courtesy, the University Museum, Philadelphia, Pennsylvania

OPPOSITE: Courtesy, Southwest Museum, Los Angeles, California, photograph by H.G. Barley

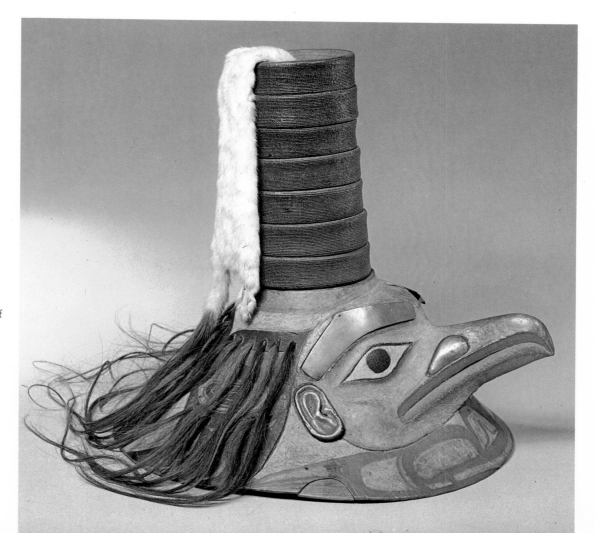

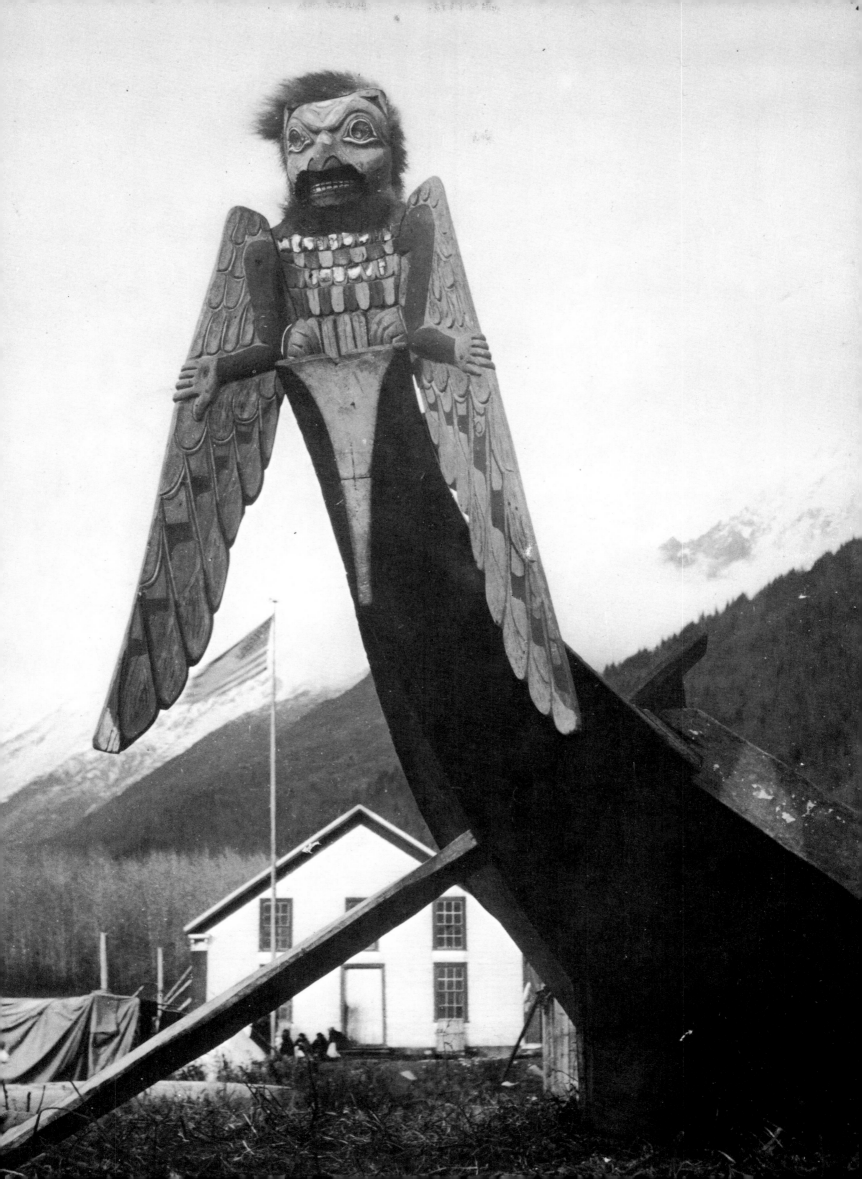

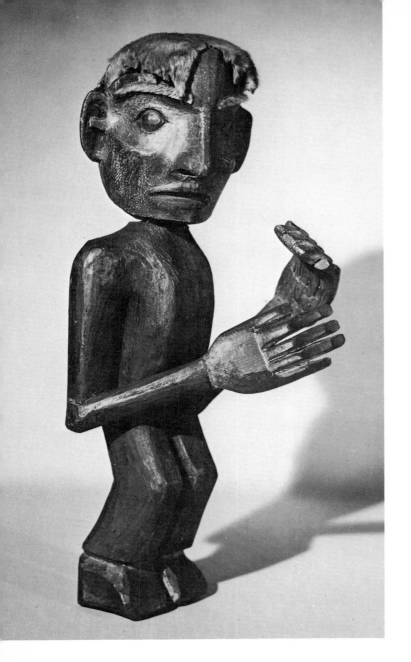

THE WOODCARVING of the Northwest Indians has long been considered the finest in the world. European travelers of the nineteenth century in the northern Pacific realized its distinction and fine examples can be seen today in museums from London to Leningrad. A wooden doll (*left*) made by the Nootkas of British Columbia has a movable head. From the same region comes the forceful carving of a woman (*below*) holding her bundled child in a decorated cradle. The carving (*opposite, top*) depicts a Caesarian birth, an episode from the Bear Mother legend. The tobacco used for the ceremonial pipe (*opposite, below*) arrived in the Northwest after traveling nearly around the world. From Virginia to England, across Europe to Russia, the crop returned to this continent in trade between Siberia and Alaska.

The World's Finest Woodcarving

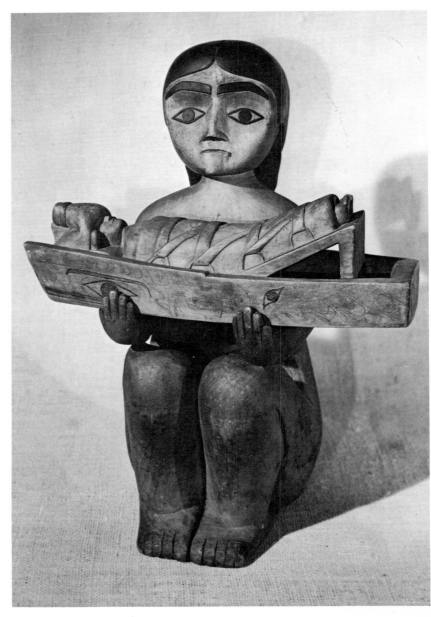

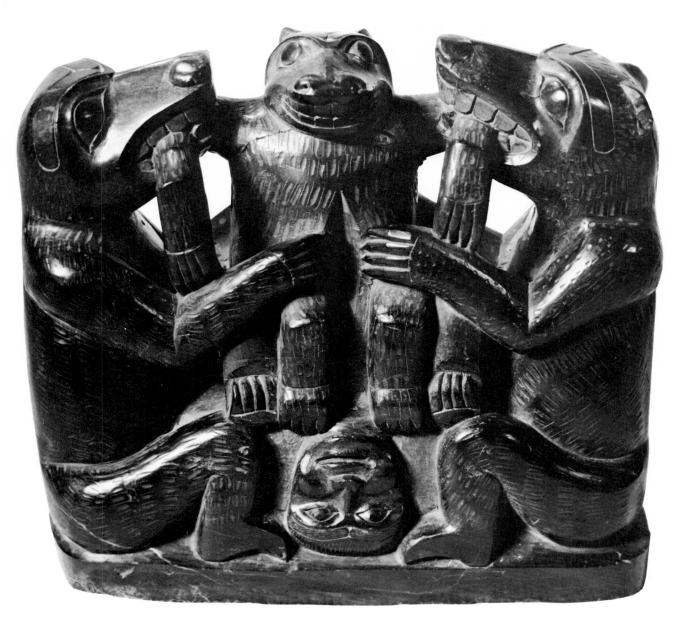

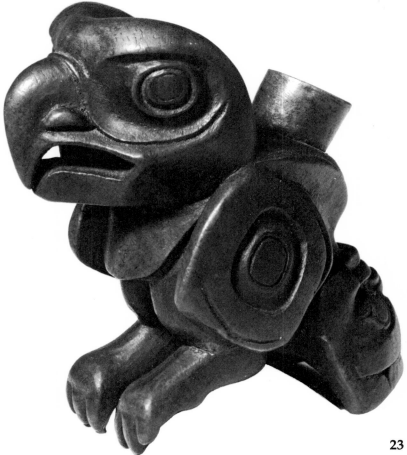

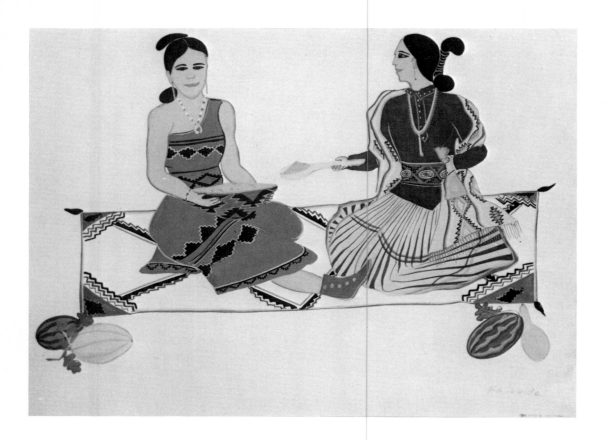

Living Tradition of Ancient Forms

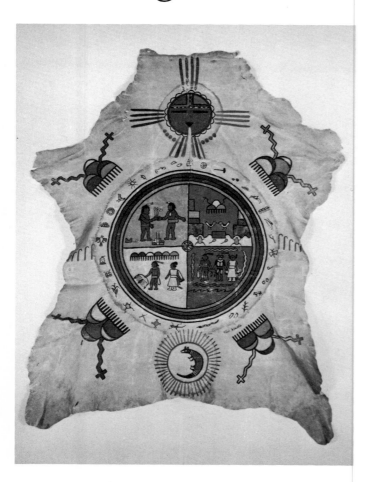

"THE RESERVATION is my inspiration," says the contemporary Navaho R.C. Gorman, painter of the seated, shawled woman (*opposite, below*). Today, although many Indians paint in the modern idiom, their work still expresses their underlying traditions. Another Navaho painter, Narcisco Abeyta, expresses himself in themes that are more clearly Indian: " . . . I stayed with the primitive," he has said. His watercolor (*above*) pictures a Navaho harvest. *The Legend of the Snake Clan* (*left*) by the Hopi artist Fred Kabotie is painted on hide in a tradition as old as the Indian himself. Julian Martinez, the painter of the ceremonial figure (*opposite, above*) is the husband of the famous potter Maria Martinez of Ilsandefonso, New Mexico.

ABOVE, LEFT AND OPPOSITE, ABOVE: Courtesy, the Museum of the American Indian, Heye Foundation, New York
OPPOSITE, BELOW: Photograph by Jerry Jacka

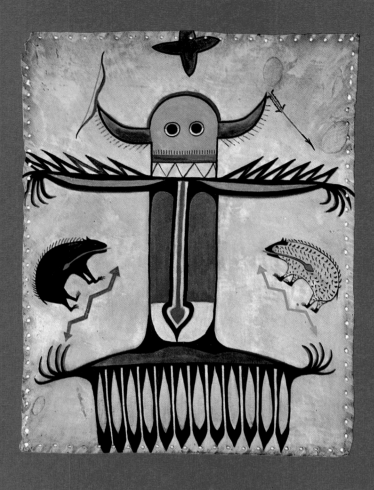

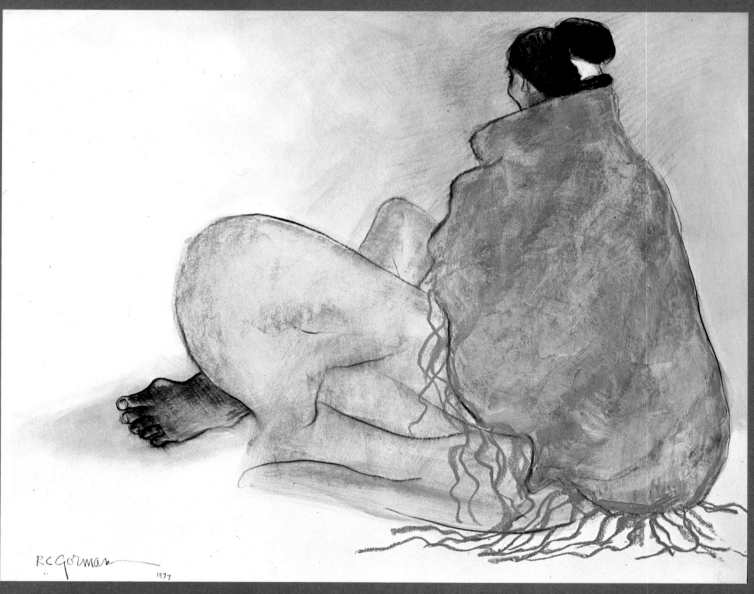

RCGorman

1977

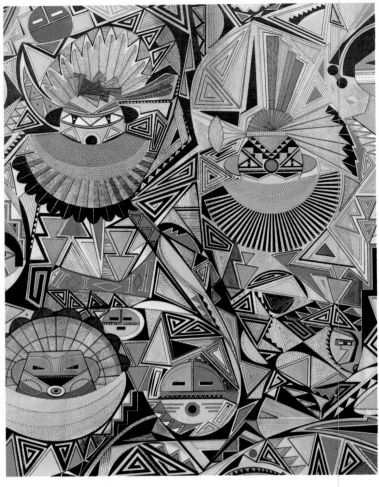

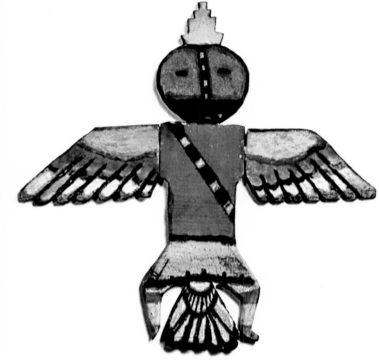

THE PAINTING (*above*) titled *Emergence of the Sun Society* is by Helen Hardin, among the foremost of today's Indian painters. Her expression is contemporary, but the wellspring of her sources remains deeply Indian. The painting by the Hopi Riley Quoyavema (*opposite*) derives from the Santa Fe school; the two large headdresses portray butterfly women with a kachina. The wooden altar ornament (*above, right*) is Zuñi and may represent the bird as a messenger.

The Hopi kachina doll (*right*), in striking costume, represents the Spirit of the Cloud.

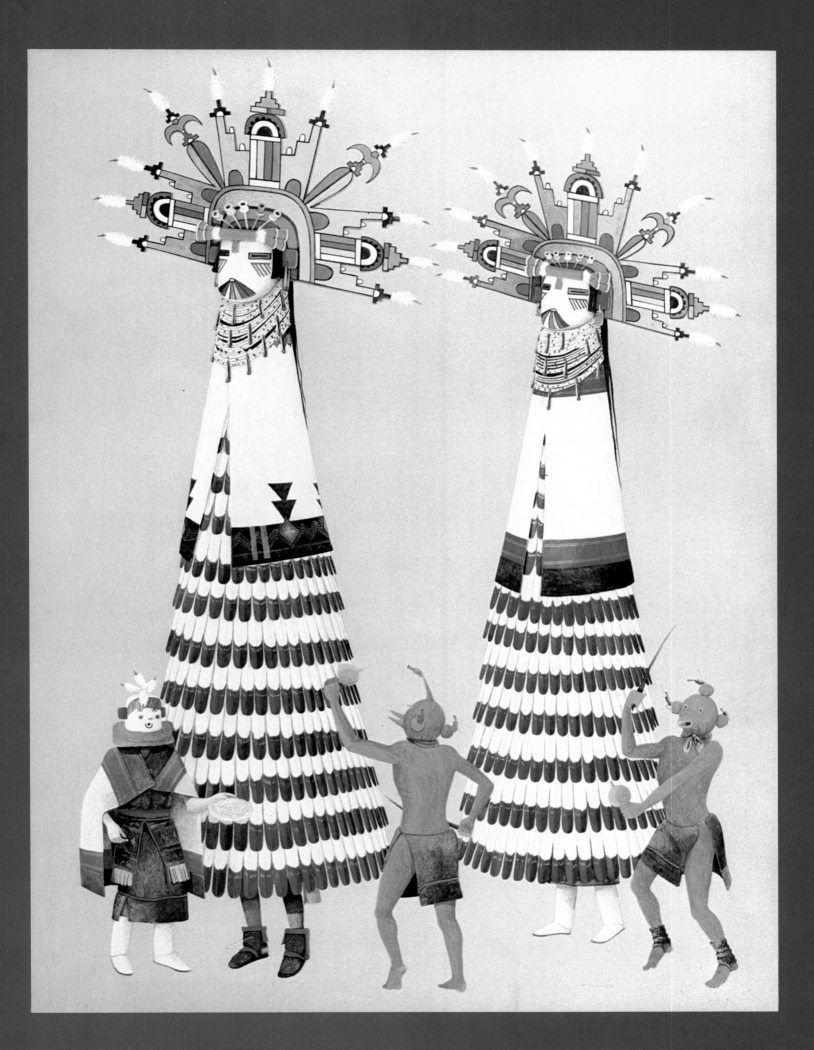

Face and Form Through Indian Eyes

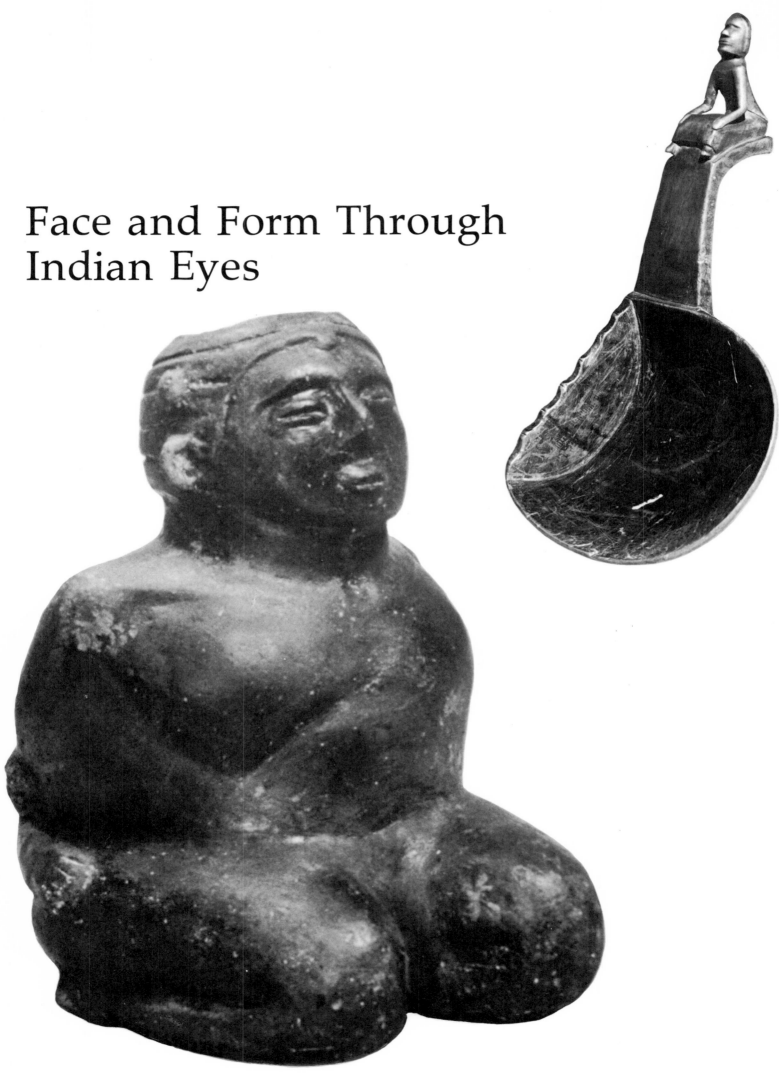

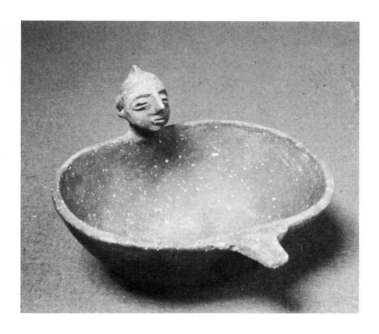

DESPITE HIS preoccupation with symbolic renderings of animals and his love of abstract patterns in design, the Indian has not overlooked the human face and figure in his art. The ancient stone figure (*opposite, below*) is a male prisoner in the shape of an effigy jar. From the nineteenth century comes a minutely realized portrait (*right*) of a uniformed European—perhaps a sea captain—seen through the eyes of a Northwest craftsman. The mere joy of decorating an everyday utensil is an ancient art; the pottery bowl (*above*) adorned with a human face, is prehistoric; the wooden ladle (*opposite, above*) from Ohio, was carved in the 1700s.

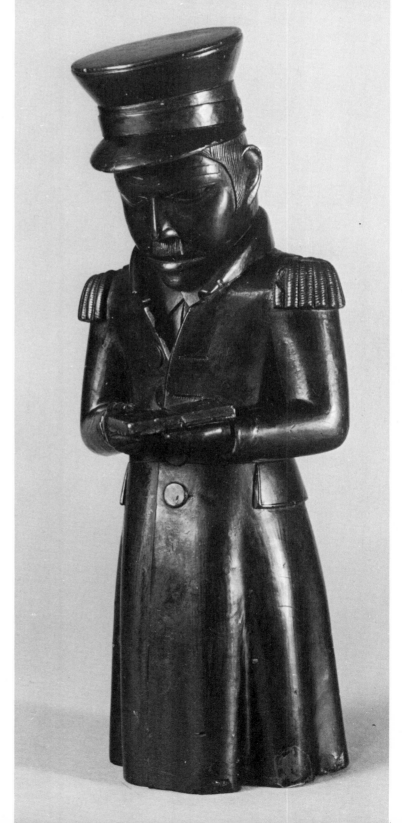

OPPOSITE: Courtesy, the Museum of the American Indian, Heye Foundation, New York, photograph by Carmelo Guadagno
ABOVE: Courtesy, the Museum of the American Indian, Heye Foundation, New York, photograph by Carmelo Guadagno
RIGHT: Courtesy, George Terasaki, New York

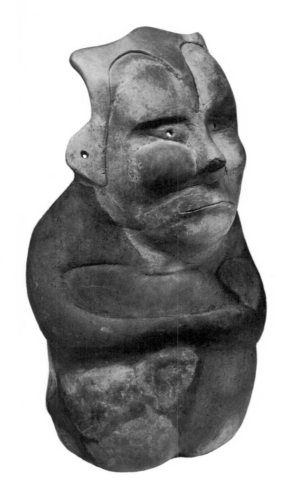

Transmitting Tradition Through Toys

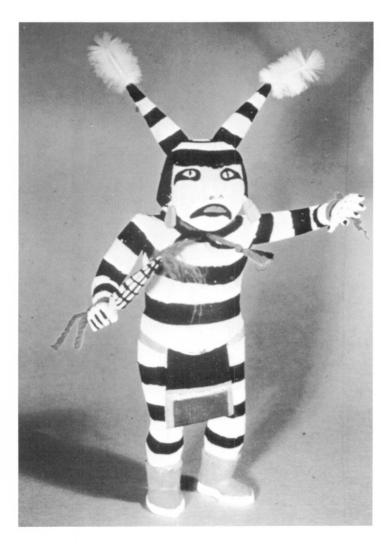

THE KACHINA DOLLS (*opposite*), which look so human, are in fact educational toys made to convey and to explain to children the meaning of the true kachina. The dolls are lovingly carved and painted, then presented to children before a Hopi ceremony so that the children will recognize the kachina spirit forms as they are enacted. The clown figure (*left*), known as the *paiyakyamu*, is also a Hopi creation. The adult who dons a kachina mask loses his own identity and transforms himself into the kachina spirit he represents.

From an archeological site in Florida comes an effigy jar (*above*) in the shape of a monkey.

ABOVE AND LEFT: Courtesy, the Museum of the American Indian, Heye Foundation, New York, photograph by Carmelo Guadagno
OPPOSITE: Courtesy, Jonathan and Philip Holstein, photograph by Edward Brennan

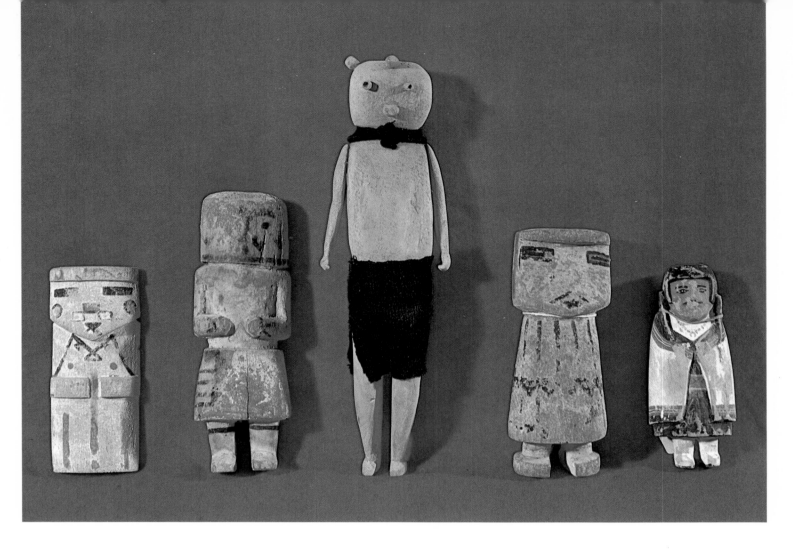

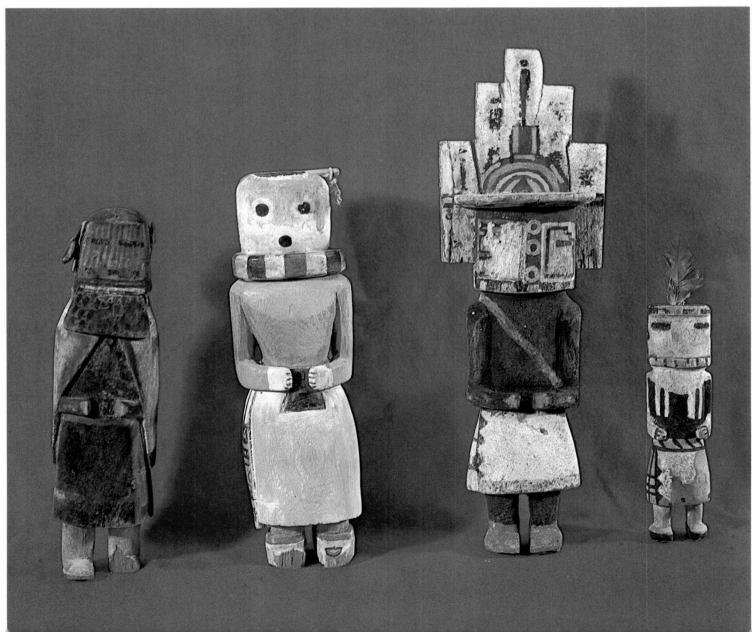

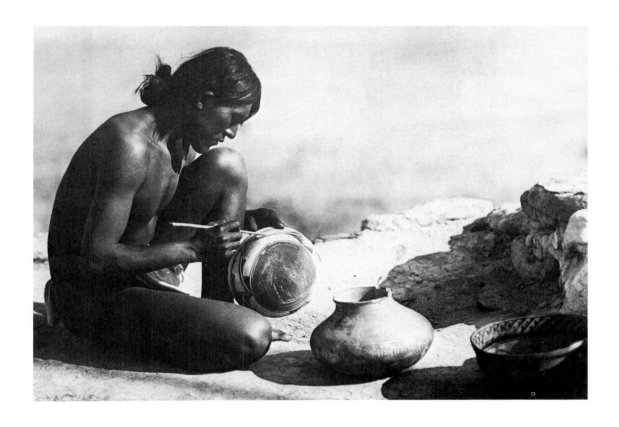

Tribal Designs that Stayed Alive

SOME TWO THOUSAND years ago, the art of pottery traveled north from Mexico and reached the ancestors of today's Pueblo people of the Southwest. The earliest pots were fashioned primitively by applying clay to baskets and baking them in the sun. As more sophisticated methods came into use, each tribe began to produce its own distinctive decoration—geometric patterns, symbolic animals, floral designs, the human figure. Over the centuries all these elements have been used, then discarded, later revived. The young Pueblo Indian (*above*) is applying his design with a stick. The girl (*right*) fills a water jug of Hopi design. The effigy jar (*opposite*) was made in the late nineteenth century by the Yuma of Arizona.

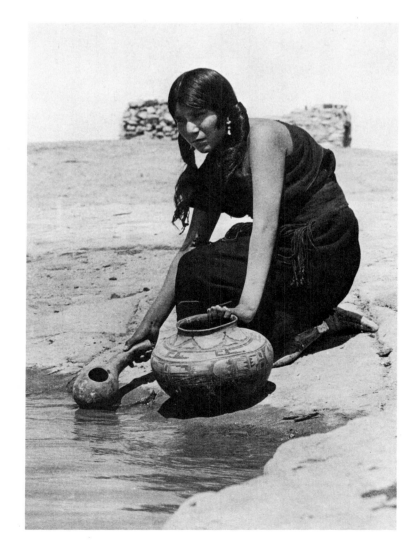

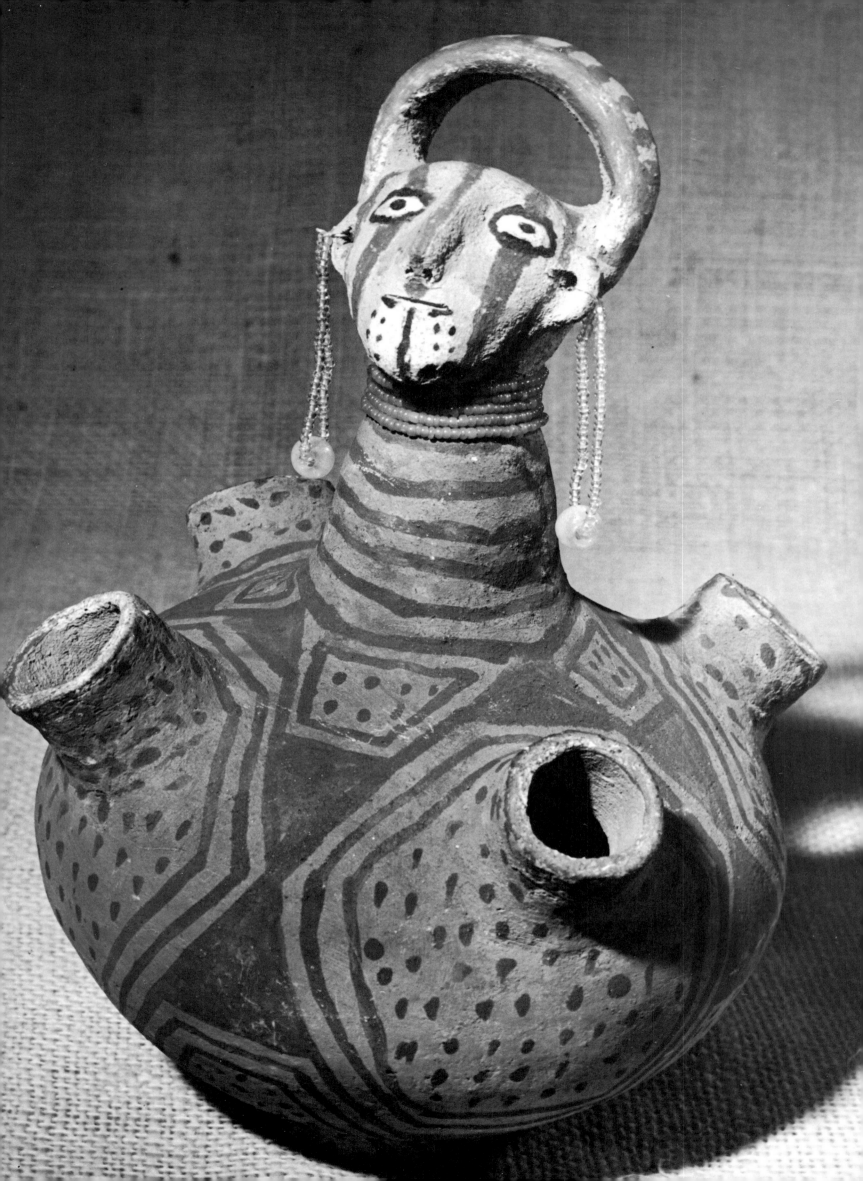

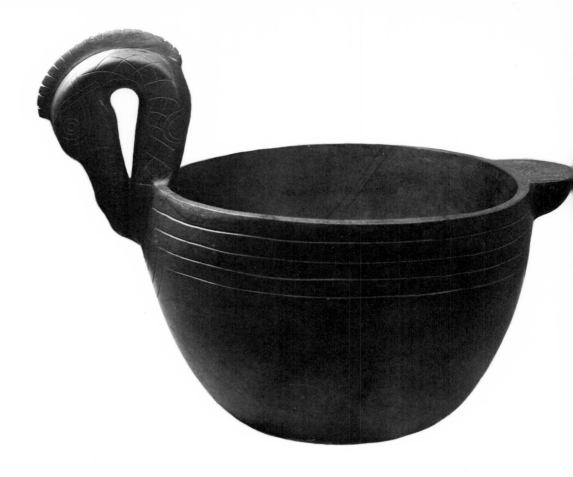

AMONG THE MOST famous and one of the few undamaged pieces of prehistoric pottery is the crested duck (*above*). Made of diorite, it was found in an Alabama site and is at least four hundred years old. Found in an ancient mound in White County, Georgia, is the bird (*opposite, above*) perched on the rim of pottery-pipe bowl. The plate (*opposite, below*) was made by a now-vanished tribe that once lived in the valley of the Mimbres River of New Mexico. These potters used designs that ranged from precise geometric patterns to abstractions of the human form. In 1919, in the pueblo of San Ildefonso, New Mexico, Maria Martinez and her husband, Julian, created a new style of pottery. Maria made highly polished blackware (*below*), which her husband then adorned with contrasting designs in dull black.

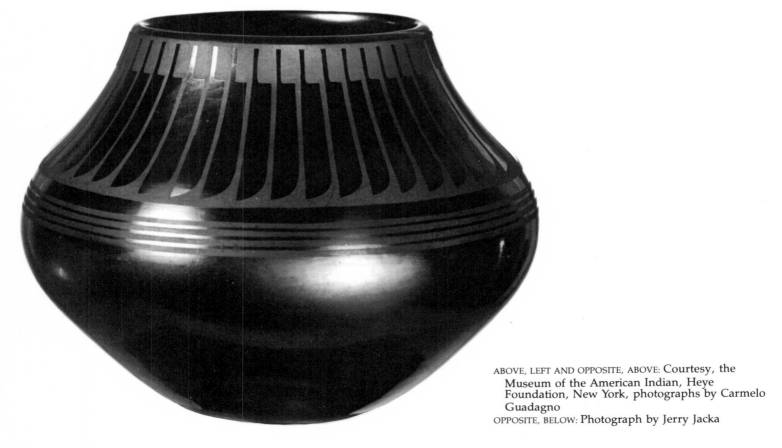

ABOVE, LEFT AND OPPOSITE, ABOVE: Courtesy, the Museum of the American Indian, Heye Foundation, New York, photographs by Carmelo Guadagno
OPPOSITE, BELOW: Photograph by Jerry Jacka

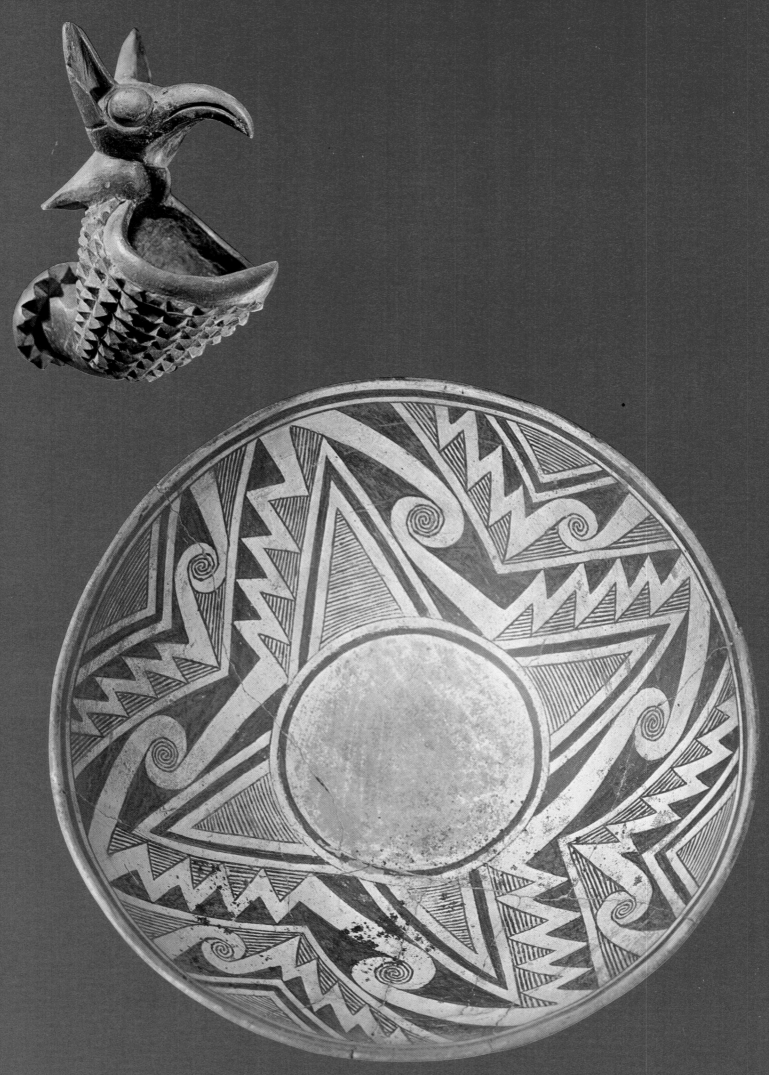

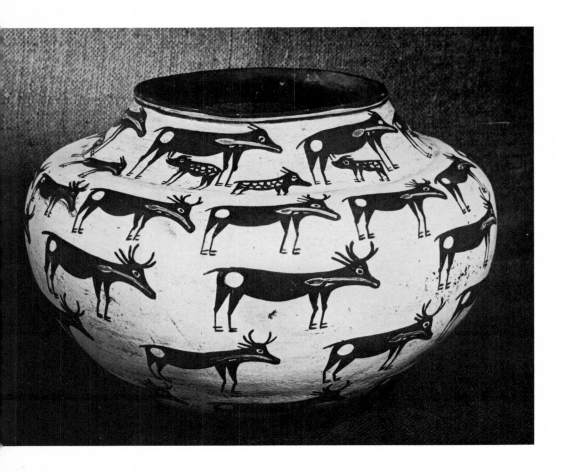

WEARING HER traditional jewelry and heavy cloth leggings to protect her from the desert's cactus spikes, an Acoma woman (*right*) paints designs on her pottery. It takes training and skill to apply a geometric pattern to a curved surface, and the technique was generally handed down from older to younger women. Although the designs seldom altered radically, each woman had her own distinctive style. The pot (*above*) with animals showing the heartline is instantly identifiable as the work of a Zuñi potter. The little pottery figures (*opposite*) are the handiwork of Yumas. They were made at the turn of this century specifically for tourists. Despite the prevalence of tourists today, the art of pottery is dying out among the Pueblos and these charming figurines are no longer made. Boldness and motion characterize the work of the world-famous potter Rachel Nampeyo (*opposite, center*) who, in the early years of this century, revitalized Hopi designs.

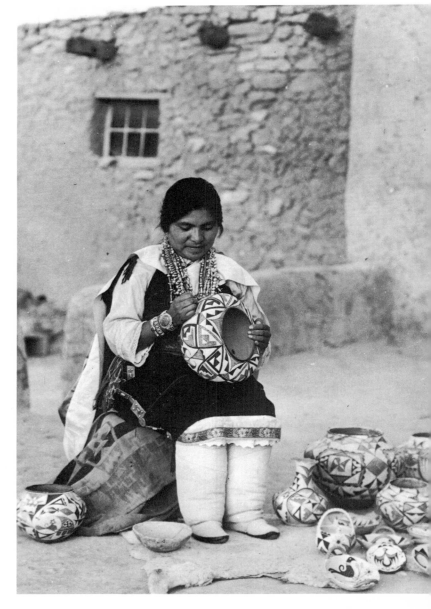

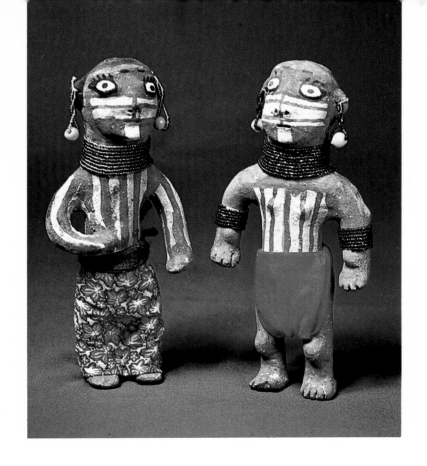

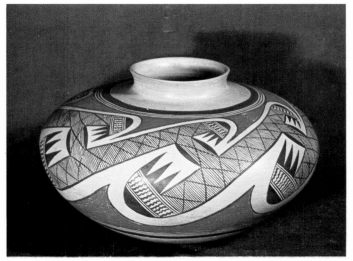

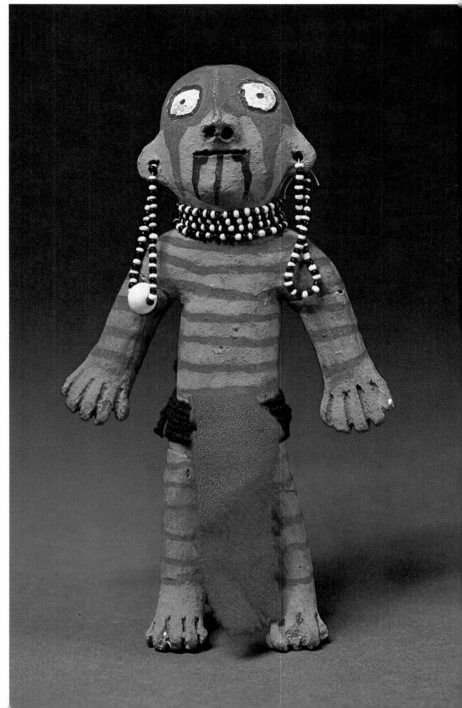

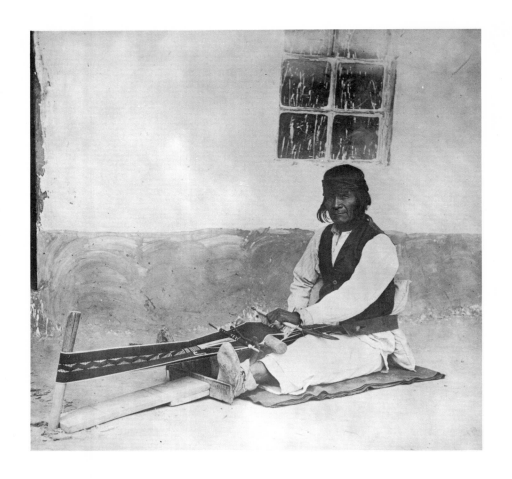

Belts, Blankets, Buttons and Hides

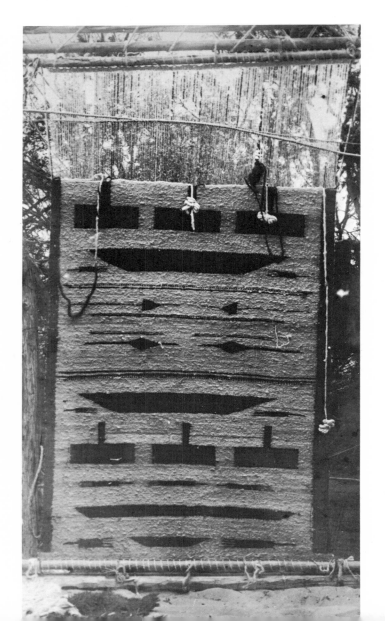

WHEN THE SPANISH conquistador Coronado first came to the Southwest, the Indians gave him precious cotton and valued turquoise as peace offerings. Weaving cloth has a long history among the Pueblos, and men were the traditional weavers. The Cochiti Indian of New Mexico (*above*) is fulfilling his tribal role. The Spaniards introduced sheep in the seventeenth century and the Navahos became weavers, too. They learned the skill from the Pueblos, and the blanket (*left*) reflects a Pueblo-inspired design. In the Northwest, hides also belonged in the Indian's wardrobe. The walrus hide (*opposite, below*), decorated with a shark and two sea monsters and the blanket (*opposite, above*), with its bear design carried out in buttons, were both made by the Tlingit of Alaska.

LEFT AND ABOVE: Courtesy, the Museum of the American Indian, Heye Foundation, New York
OPPOSITE, ABOVE AND BELOW: Courtesy, the Museum of the American Indian, Heye Foundation, New York, photograph by Carmelo Guadagno

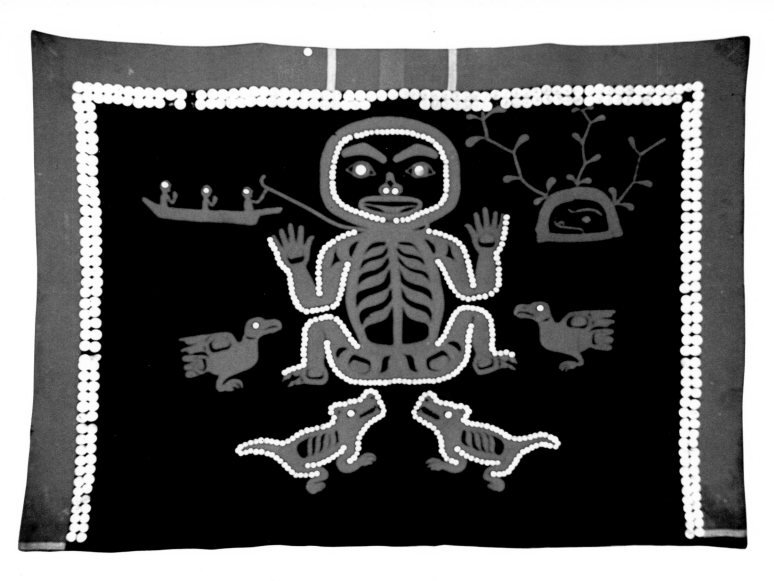

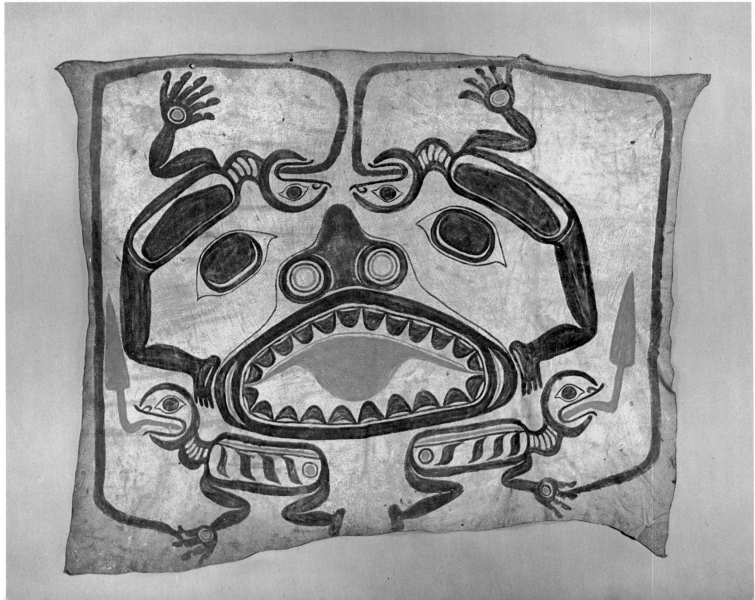

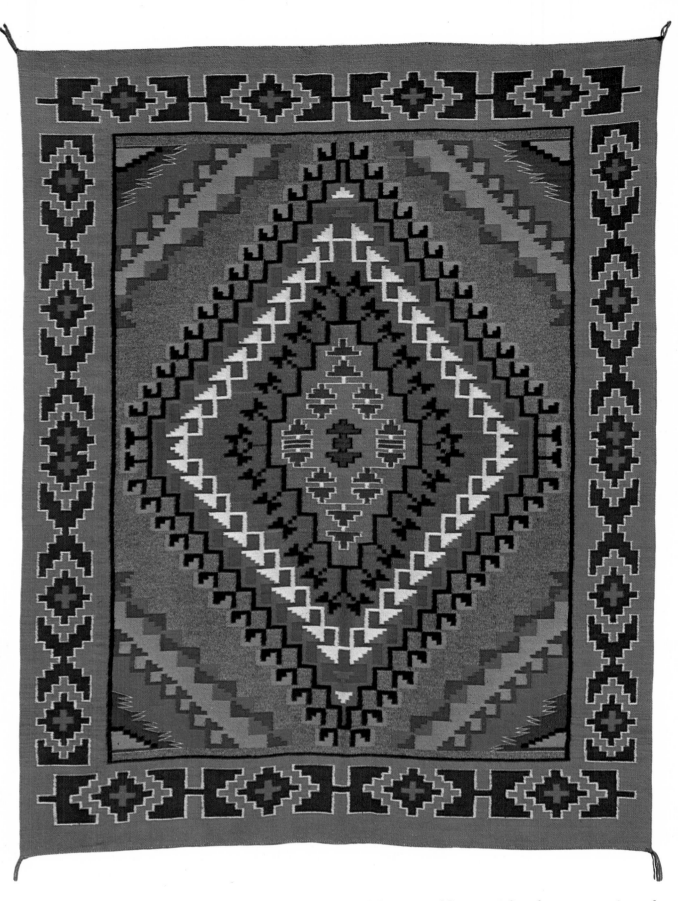

ABOVE: Courtesy, *American Indian Art Magazine*, photograph by Jerry Jacka
OPPOSITE, ABOVE: Courtesy, George Terasaki, New York
OPPOSITE, BELOW: Courtesy, the Museum of the American Indian, Heye Foundation, New York, photograph by Carmelo Guadagno

WHEN THE NAVAHOS first began weaving, they used natural dyes and simple patterns but later, with the unravellings of brightly dyed European cloth, stronger colors and more complex designs appeared. Today, there is considerable interest in reviving earlier colors and designs. The three blankets (*opposite*) are traditionally simple. Among the Navaho, it is the woman who is the weaver and the blanket (*above*) is the creation of a contemporary weaver, Philomena Yazzie.

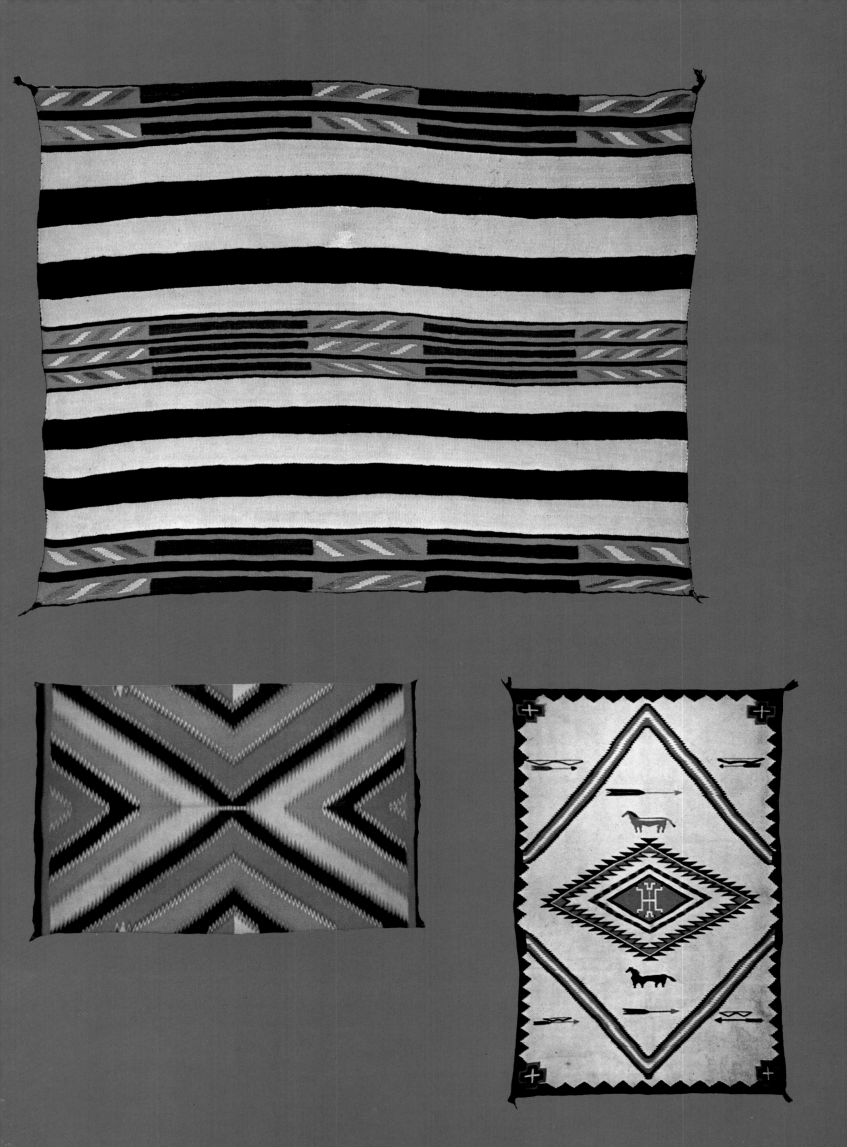

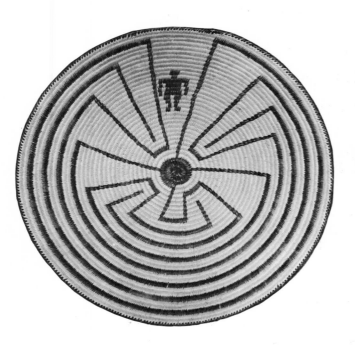

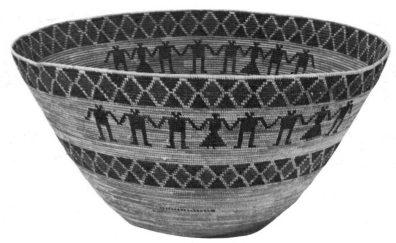

Household Objects
Transformed into Art

BASKET-MAKING has been called the mother of weaving. In its primitive beginnings, the basket was an everyday, necessary household article for storing the seeds and nuts which were the tribe's sustenance. Gradually pride of possession transformed baskets into handsome as well as practical objects. The tray (*above*) was woven by the Pima Indians of Arizona in the early years of this century. From California, a region whose Indians were especially skilled weavers, come the four

baskets showing contrasting designs. In the first the human figure (*above, right*) has been transformed into a geometric frieze; the second (*below*) uses emphatic lines to create a vivid design. The depth of the third and fourth baskets (*opposite, below*) indicate that they were used for storage. On the other hand, the flatter baskets made excellent dice boards for the California Indians, who loved to gamble. Split acorns served as dice. The exceptional grace of the tray (*opposite, above*) is a design favored by the Apaches of the Southwest.

ABOVE, RIGHT: Courtesy, The Museum of the American Indian, Heye Foundation, New York
OPPOSITE, ABOVE: Courtesy, Hastings House, Essex, Connecticut.
OPPOSITE, BELOW: Courtesy, Southwest Museum, Los Angeles, California.

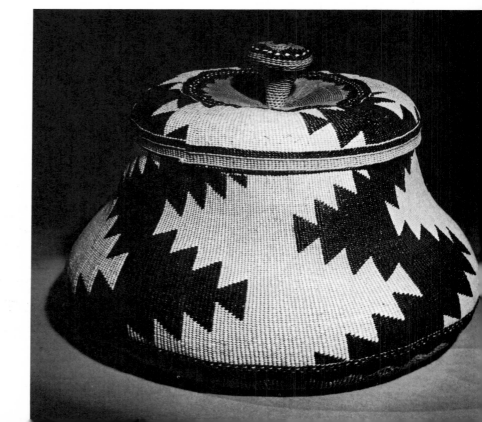

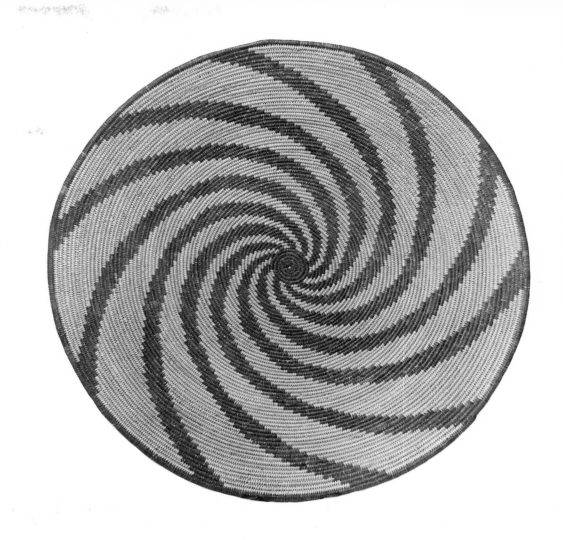

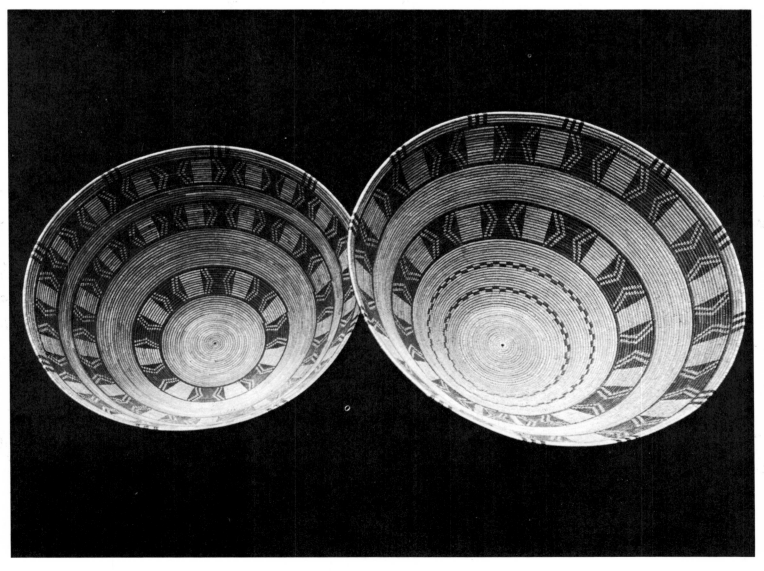

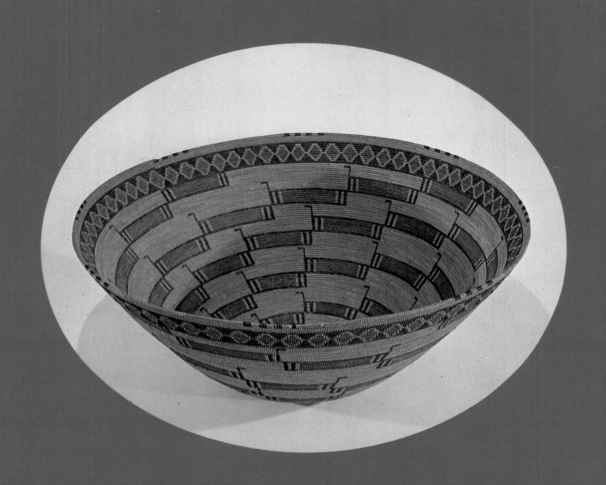

An Art Once Woven
into the Fabric of Life

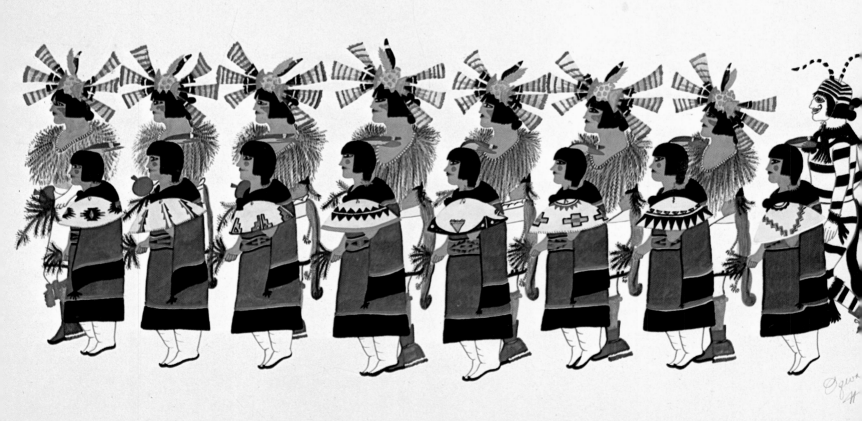

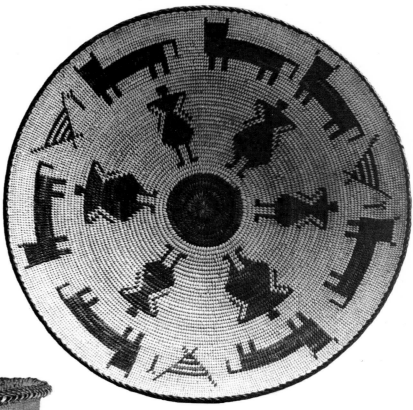

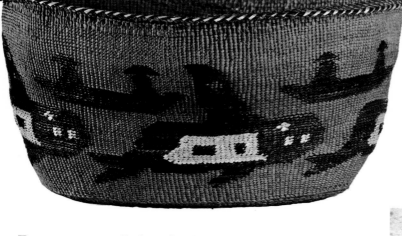

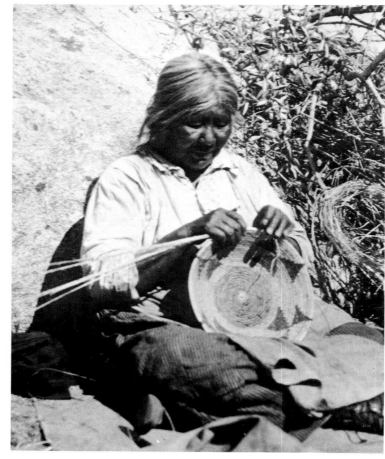

THE COLORS OF Indian baskets tend to be muted shades of browns, subtle reds, blacks and creams. The strong appeal of the basket lies in its cumulative effect on the viewer rather than in a dazzling first impact. The Yakut tribe of California wove the classic basket (*opposite, above*); from the California Pimas comes the tray (*above, right*), which departs from a geometric design to show women and a herd of animals. A whale hunt (*above*) is woven into basket form by the Northwest Nootkas. What was once a common sight—an Indian woman (*right*) working on her basket—is now seldom seen, for modern world has destroyed the desire and the skill. Oqwa Pi, a contemporary Pueblo artist, painted *Basket Dance* (*opposite, below*) in which the eight participants each carry a basket of different design.

OPPOSITE, ABOVE: Courtesy, George Terasaki, New York
OPPOSITE, BELOW: Courtesy, the Museum of the American Indian, Heye Foundation, New York, photograph by Carmelo Guadagno
ABOVE, RIGHT: Courtesy, Hastings House, Essex, Connecticut
ABOVE: Courtesy, Hastings House, Essex, Connecticut
RIGHT: Courtesy, the Museum of the American Indian, Heye Foundation, New York

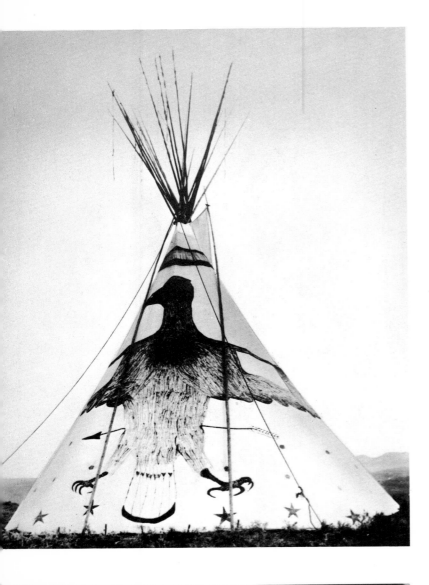

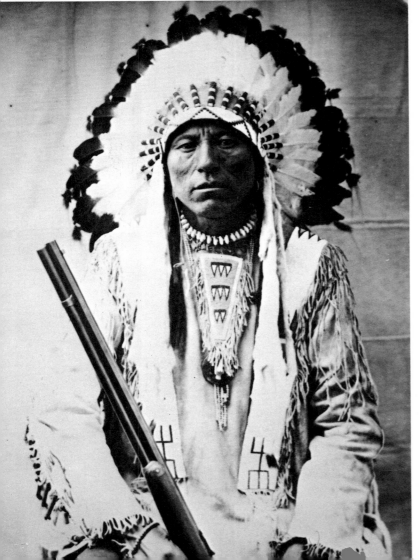

FROM THE SOUTHWEST came the Spaniard's horse; from the East came firearms and the fur trade, so that by the middle of the eighteenth century, Indian tribes, which had long led a settled farming life on the edge of the Great Plains with occasional hunting forays, now moved onto vast grasslands. For little more than a brief, brilliant century they organized a military, nomadic society, hunted the buffalo and gave birth to the white man's myths of Western novels and movies. The Blackfoot from Montana (*left*) epitomizes the warrior spirit. The eagle, painted on a Crow tipi (*above*) is typical of nomadic art, which is created to be easily portable. From a mound in Oklahoma (*opposite*) comes a prehistoric warrior figure.

ALL PICTURES: Courtesy, the Museum of the American Indian, Heye Foundation, New York

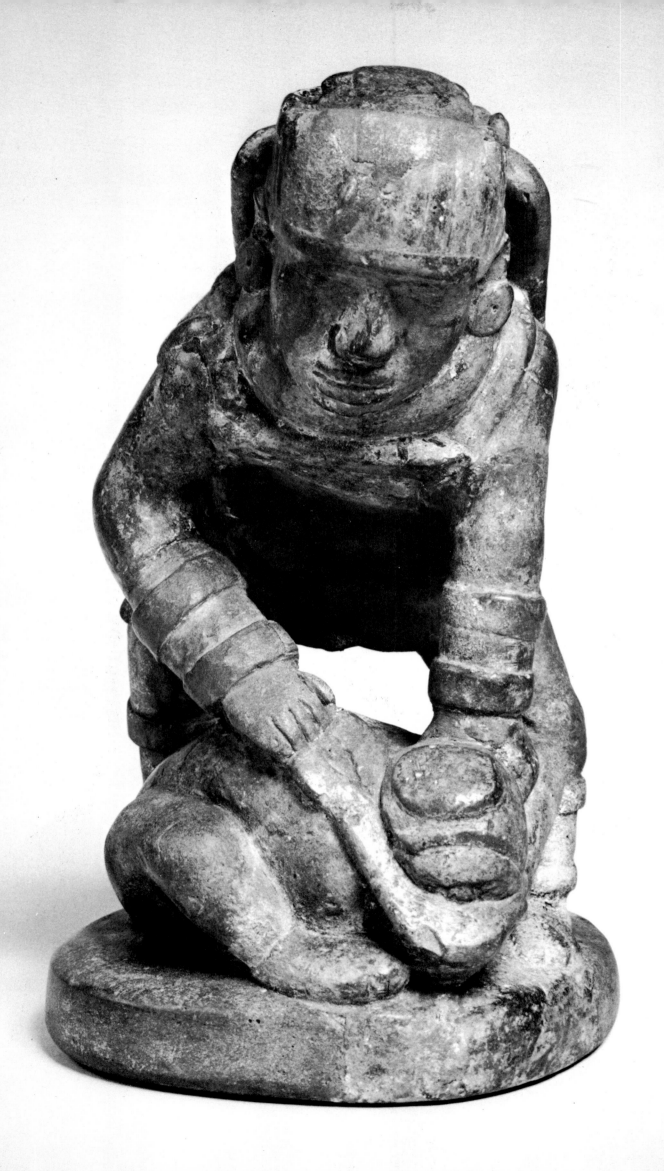

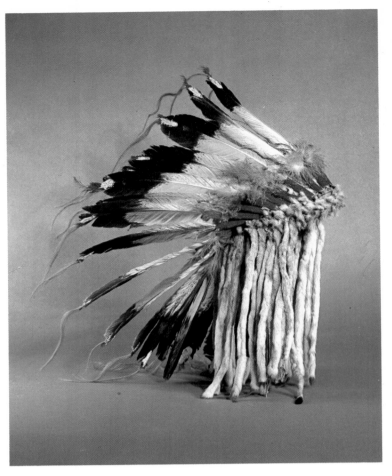

THE PLAINS INDIANS were roving bands of hunters and warriors only loosely organized into tribes. Prowess in warfare and in the hunt brought social prestige. The shield (*opposite, above*) once belonged to a warrior of what is now North Dakota. It depicts a land turtle, signifying longevity and endurance. Supernatural and magical properties were attributed to the arms men carried into battle so that it was believed, for instance, that a rawhide shield could deflect bullets. The feather bonnet (*left*) is also from North Dakota. The painting, (*below*) titled *The Man-Who-Carries-The-Sword*, shows us a Sioux in all his ceremonial regalia. The horse, which is discussed in the introduction, in his leap through space, catches for posterity that moment in the history of the Plains Indian when the vast prairies still belonged to him and his people.

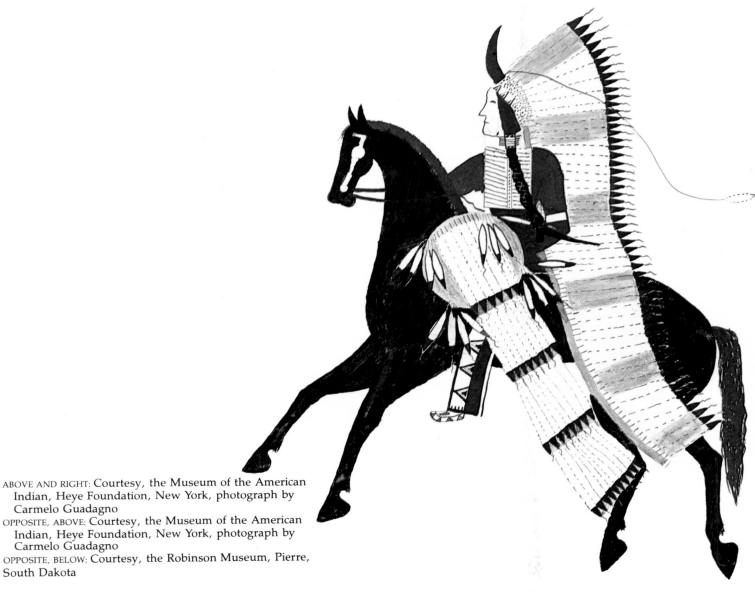

ABOVE AND RIGHT: Courtesy, the Museum of the American Indian, Heye Foundation, New York, photograph by Carmelo Guadagno
OPPOSITE, ABOVE: Courtesy, the Museum of the American Indian, Heye Foundation, New York, photograph by Carmelo Guadagno
OPPOSITE, BELOW: Courtesy, the Robinson Museum, Pierre, South Dakota

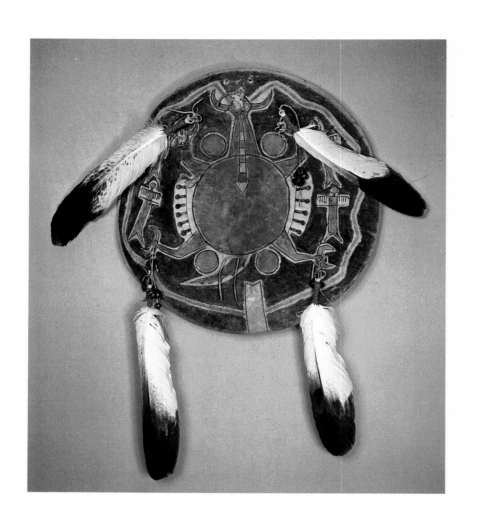

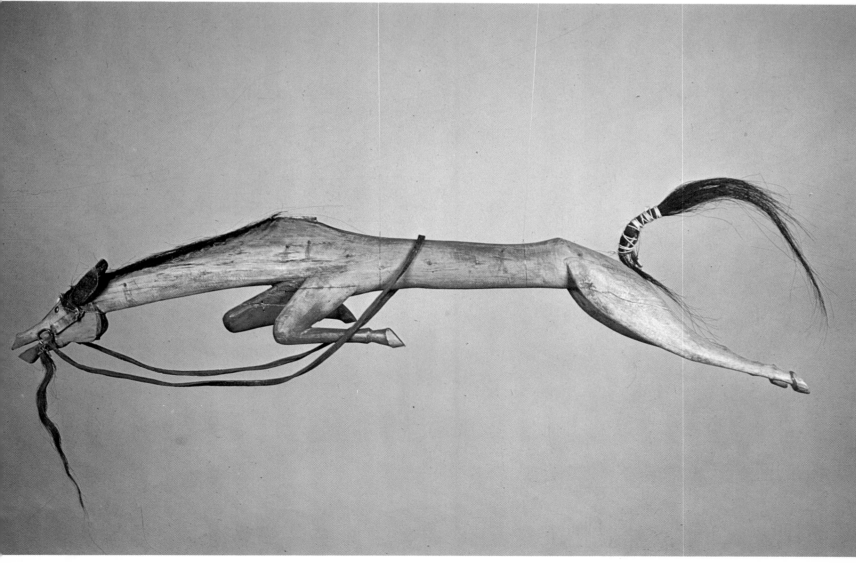

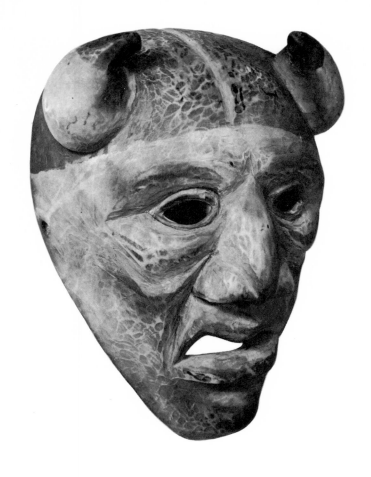

NORTH FROM TEXAS to Canada and east to the Mississippi stretched the area which the Plains Indians could once call their own. Here they depended on the buffalo for nearly all the practical needs of daily living—food, clothing and shelter. But they also incorporated the buffalo into their religious life. The straw-stuffed skull (*opposite, above*) was used in the yearly Sun Dance, in which most tribes took part. The buffalo vertebra (*opposite, below*) when painted, was transformed into a charm. That the influence of the buffalo spread beyond the Plains is evidenced by the mask (*left, above*) used by the Cherokees of North Carolina impersonating the buffalo in a dance. The painted robe (*left*) is the work of a Pueblo Indian of New Mexico at the turn of the century.

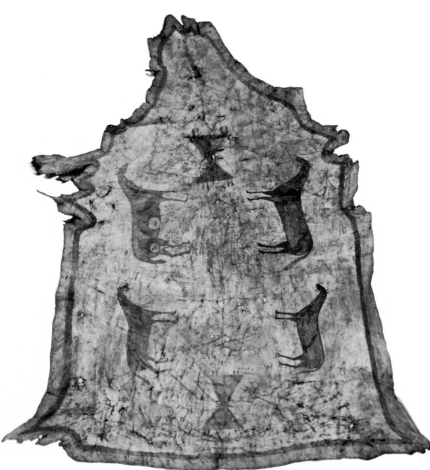

LEFT, ABOVE AND OPPOSITE, ABOVE: Courtesy, the Museum of the American Indian, Heye Foundation, New York, photograph by Carmelo Guadagno
OPPOSITE, BELOW: Courtesy, the University Museum, University of Pennsylvania, Philadelphia, Pennsylvania

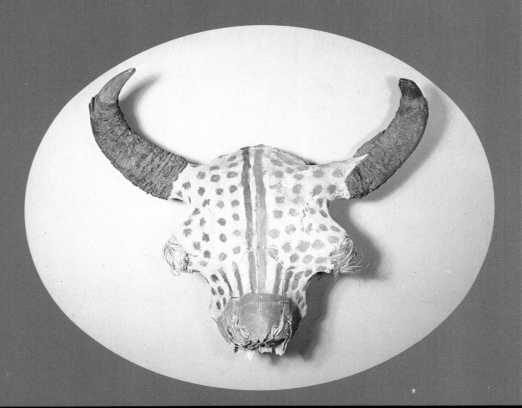

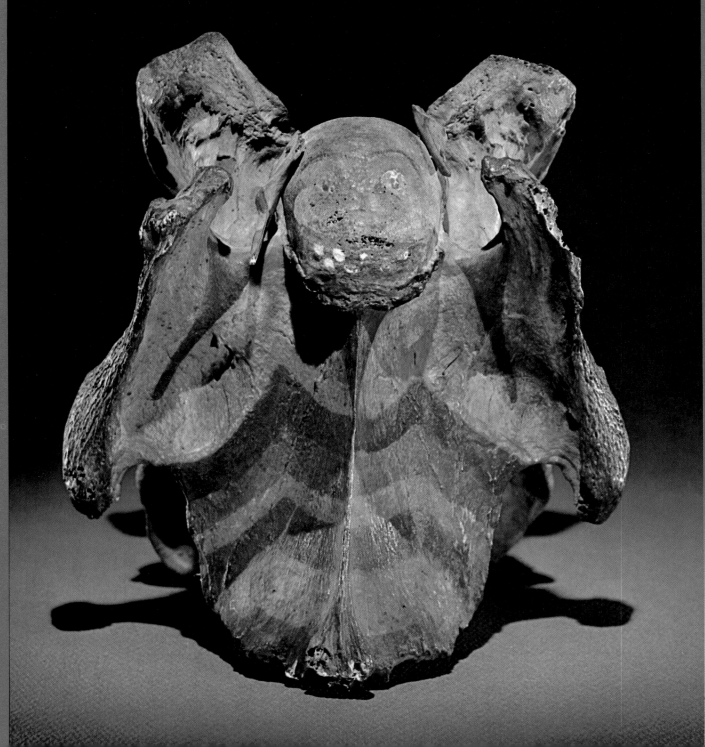

Enriching the Objects of Everyday Life

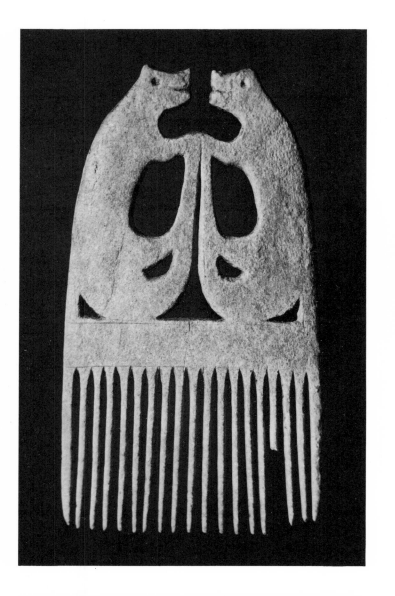

IN INDIAN EYES every object, no matter how mundane its purpose, was worthy of embellishment by painting or carving or embroidery. With skill—and often with quizzical humor—the Indian set about transforming anything and everything from a comb to a horse's bridle into an object that would give pleasure to those who used it. The comb (*left*) is of Iroquois origin and was carved in bone some four hundred years ago. The silver bridle (*left, below*) adorned a Navaho horse in the last century. The velvet vest (*opposite, above*) is an outstanding example of Chippewa beadwork from Michigan. The parfleche trunk (*opposite, center*) is made of stiff rawhide, covered in geometric designs by a Ponca Indian of Oklahoma; and the round box (*opposite, below*) of dyed porcupine quills is the work of the Micmacs of eastern Canada.

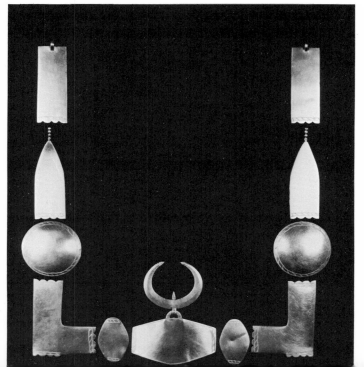

ALL PICTURES: Courtesy, the Museum of the American Indian, Heye Foundation, New York, photographs by Carmelo Guadagno

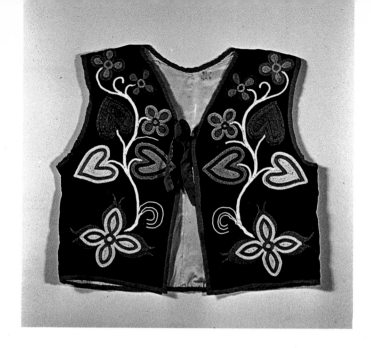

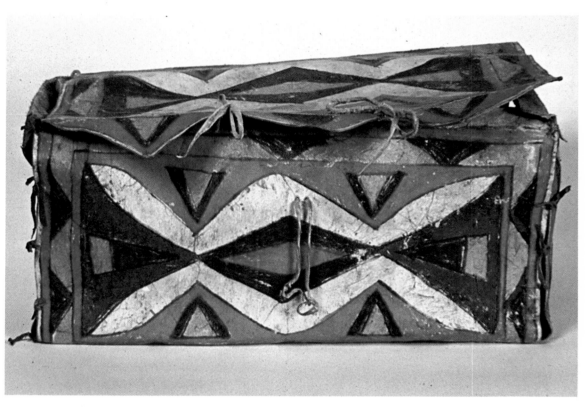

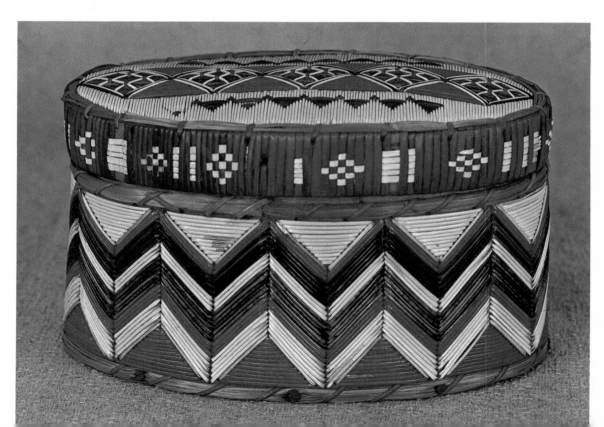

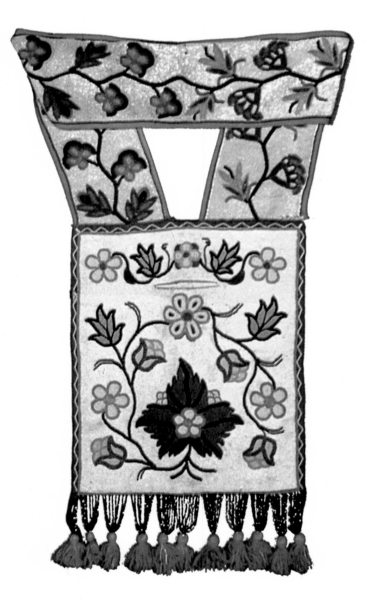

Embroidery Skills
Brought Prestige

LIKE THE HORSE and the gun, beadwork came to the Indian through trade with the European. And, perhaps because of the fur trade, it was the Plains Indians and those living near the Great Lakes who obtained beads for embroidery most readily. The work was always done by women and, as with men in hunting and warfare, special skills conferred social prestige. Among some Plains Indians, for example, exclusive craft guilds were formed for talented beadworkers. The delicately executed cradle-carrier (*opposite*) is the work of the Kutenai of Montana. The brilliant blue knife sheaf (*above*) is also from Montana but was the property of a Blackfoot warrior. The shoulder bag (*left*) was made by a Chippewa of the Great Lakes and was meant to be worn by a man on ceremonial occasions.

ALL PICTURES: Courtesy, the Museum of the American Indian, Heye Foundation, New York, photographs by Carmelo Guadagno

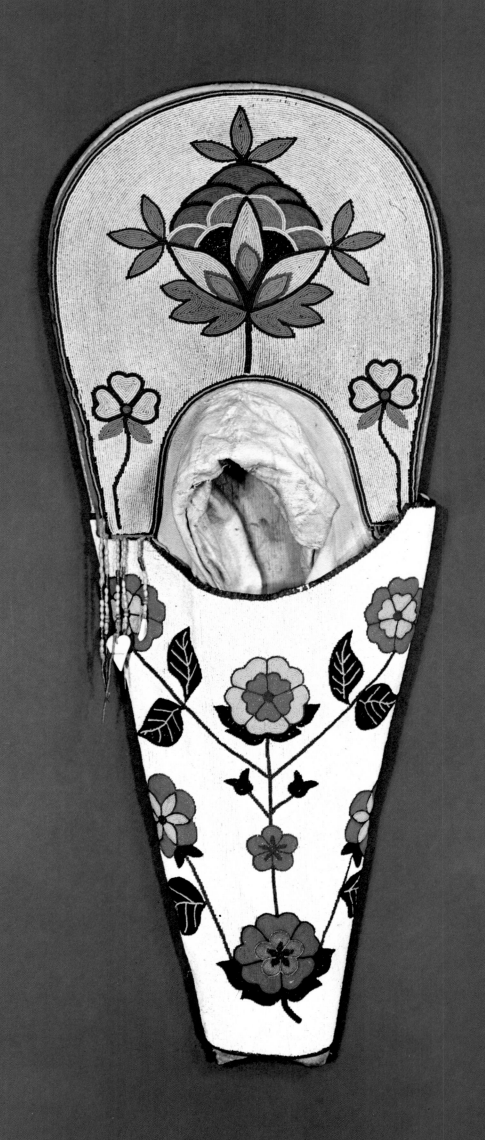

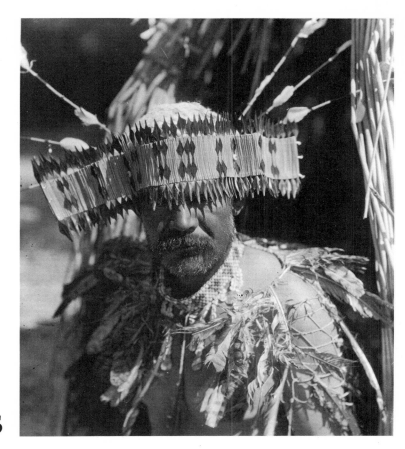

The Love and Care of Costumes

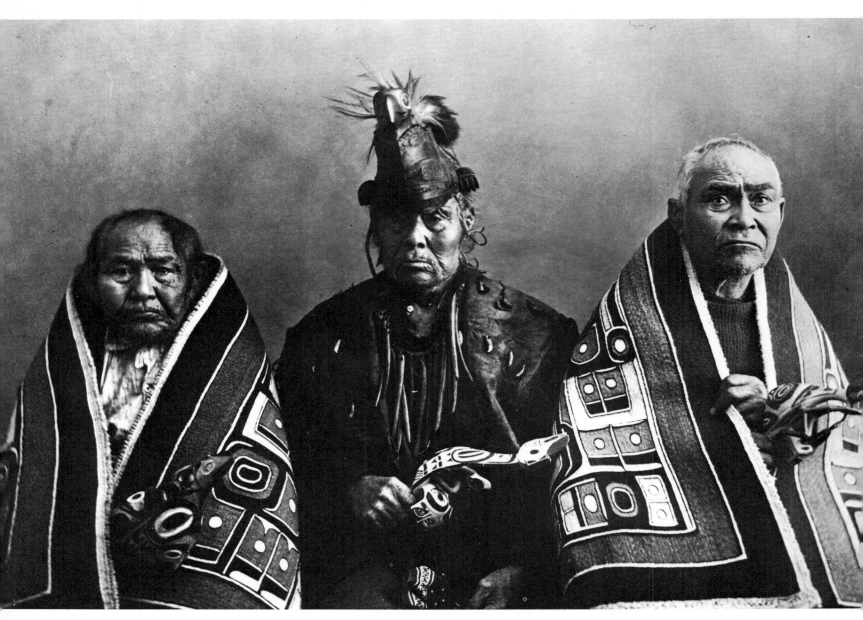

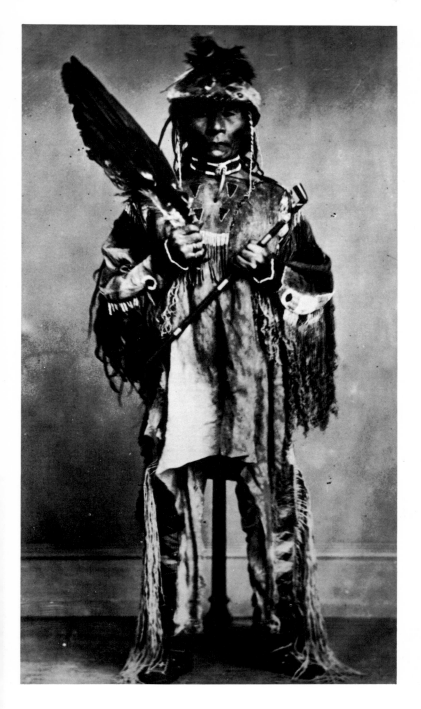

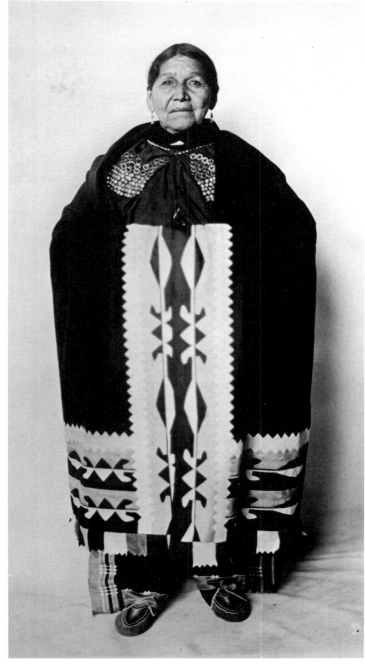

THE MAKING OF costumes was a painstaking labor of love, the wearing of them a matter of pride and display, often denoting social rank. The young Nez Perce (*above, left*) in his fringed buckskin holds his smoking pipe and an outsize eagle feather in each hand. A woman from the Delaware tribe of Oklahoma (*above*) is wrapped in a cloak made of patchwork and decorative ribbon work, which was typical of certain mid-Western tribes. The costume of open net worn by the Pomo Indian—documented by the eminent photographer Edward S. Curtis— (*opposite, above*) reflects the warm climate of central California. Splinters of wood and feathers have been artfully interwoven to make an intricate headdress with a cut feather design. In the cold Northwest, three head men of the Chilkat tribe (*opposite, below*) are wrapped in blankets of local design and hold rattles that symbolize animals.

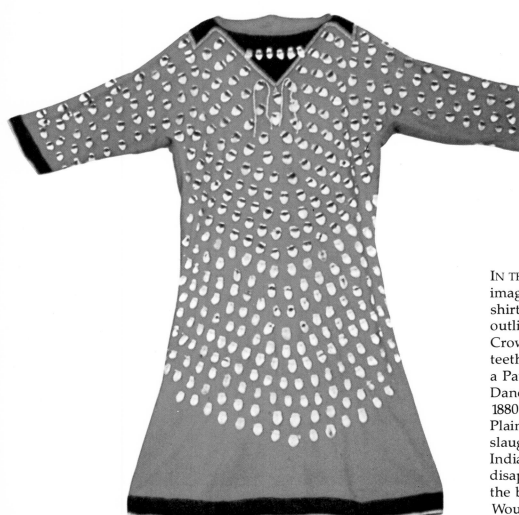

IN THE DECORATION of his clothes, the Indian made imaginative use of whatever came to hand. On a shirt made by Tlingits of Alaska, (*left, below*) buttons outline an octupus. The red dress (*left*) worn by a Crow of Montana is ornamented with imitation elks' teeth. The Ghost Dance dress (*opposite*) was worn by a Pawnee of Oklahoma at the time of the Ghost Dance movement. This messianic crusade of the 1880s· and 1890s spread like a prairie fire through the Plains Indians, a response to the white man's slaughter of the buffalo and the expropriation of the Indian's land. The movement predicted the disappearance of the white man and the return of the buffalo. It climaxed tragically in 1890 at Wounded Knee.

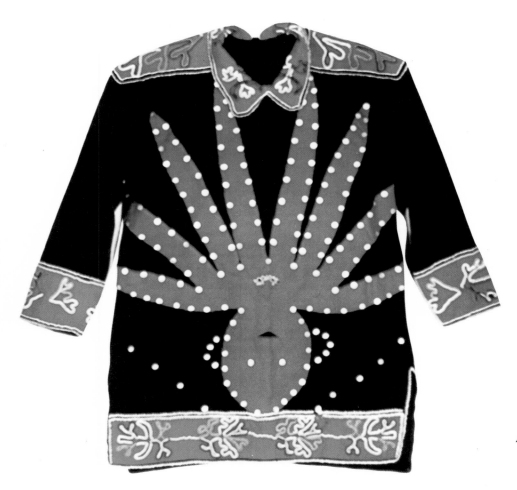

ALL PICTURES: Courtesy, the Museum of the American Indian, Heye Foundation, New York, photographs by Carmelo Guadagno

58

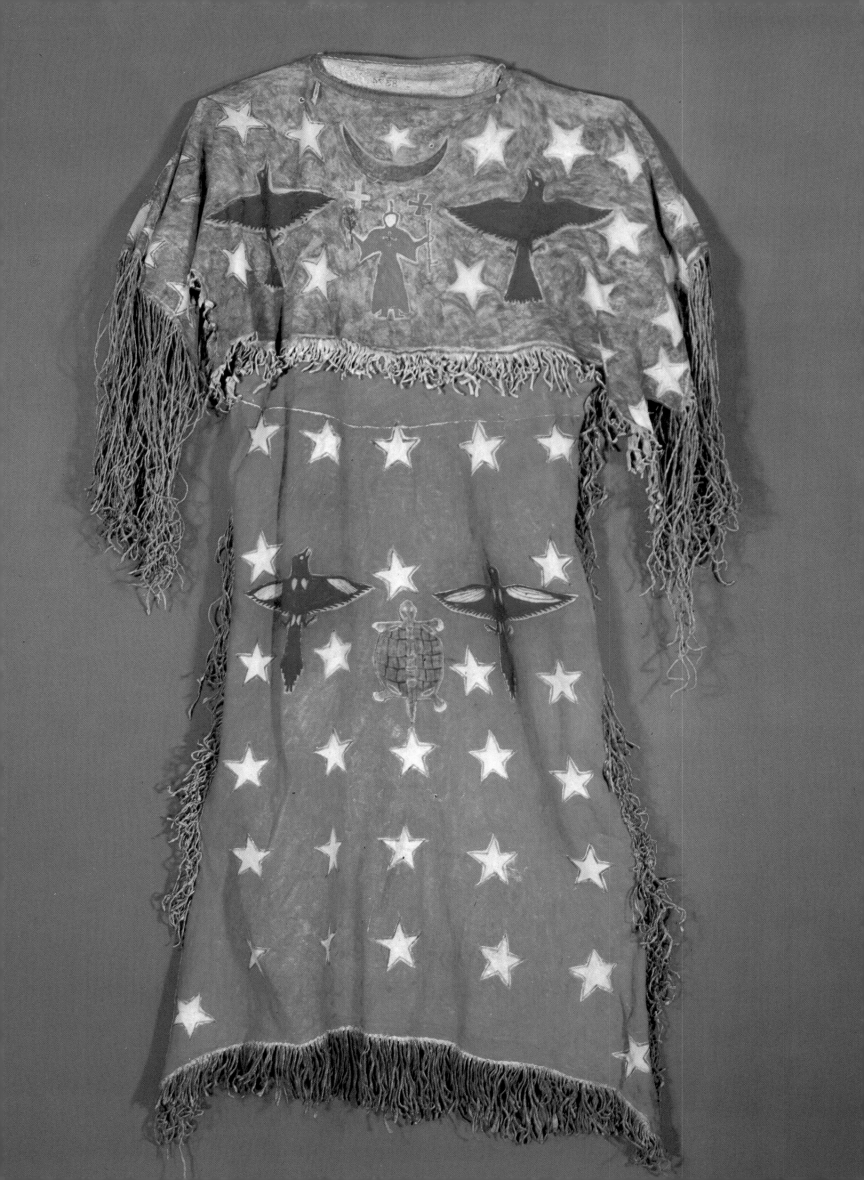

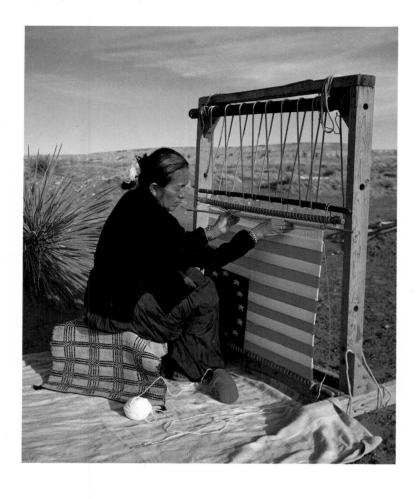

THE STRENGTH, vitality and enrichment of Indian art owes much to an imaginative adaptation of alien forms, shapes and designs. The Indian borrowed from other Indians and from Europeans and then transformed what he took. So, too, with the Stars and Stripes, which became a popular motif at the turn of the century. Salvage shoes is the name given to the boots (*left, below*) which were issued to Indians by the U.S. Government. During the last half of the nineteenth century, Indian leaders were often called to Washington on government business and arrived in national costume. This was frowned upon in official circles with the result that the Government issued western clothing to Reservation Indians. The baby bonnet (*opposite, above*) was made for a Plains Indian infant around 1900 and the beaded vest, (*opposite, below*) was embroidered by a Sioux woman for her husband. Even today, interpretations of the Stars and Stripes have not died out. With the Reservation landscape stretching beyond the loom, Navaho Mary Beetso weaves a thirteen-star American flag (*left, above*)

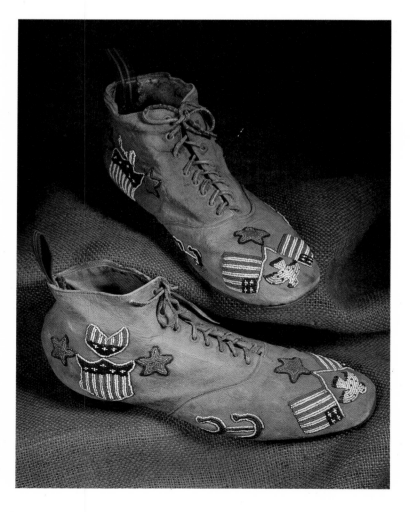

LEFT, ABOVE: Photograph by Jerry Jacka
LEFT, BELOW: Courtesy, Gallup Trading Company Museum, Gallup, New Mexico, photograph by Jerry Jacka
OPPOSITE, ABOVE: Courtesy, Hubert Guy Collection, La Mesa, California, photograph by Jerry Jacka
OPPOSITE, BELOW: Courtesy, the University Museum, University of Pennsylvania

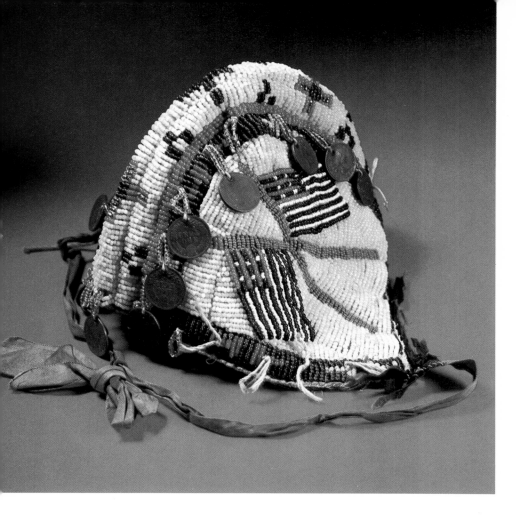

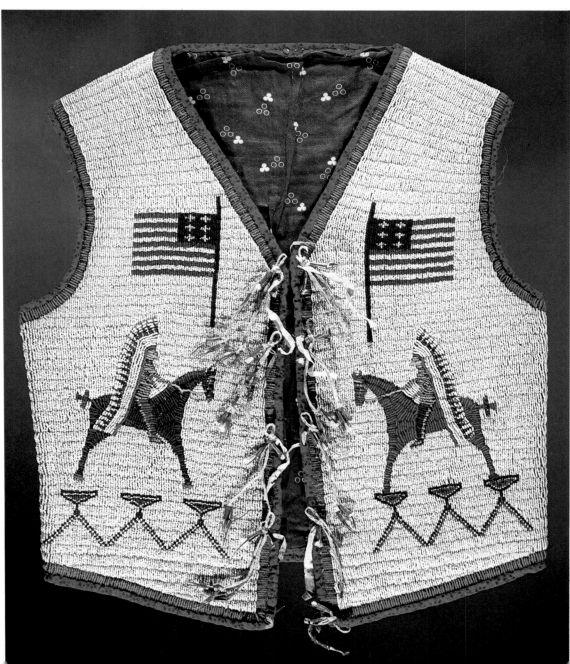

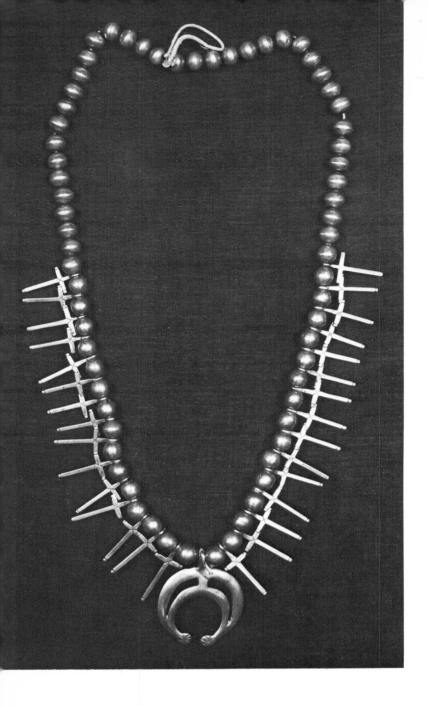

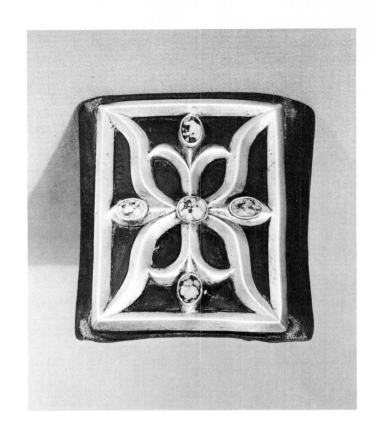

The Ancient Art of Adornment

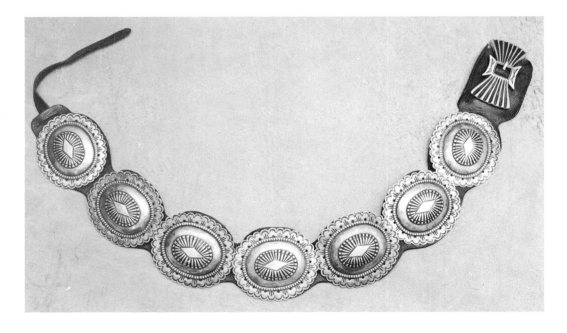

ABOVE, LEFT AND RIGHT: Courtesy, the Museum of the American Indian, Heye Foundation, New York, photographs by Carmelo Guadagno.
RIGHT: Private Collection, photograph by Joseph Martin.

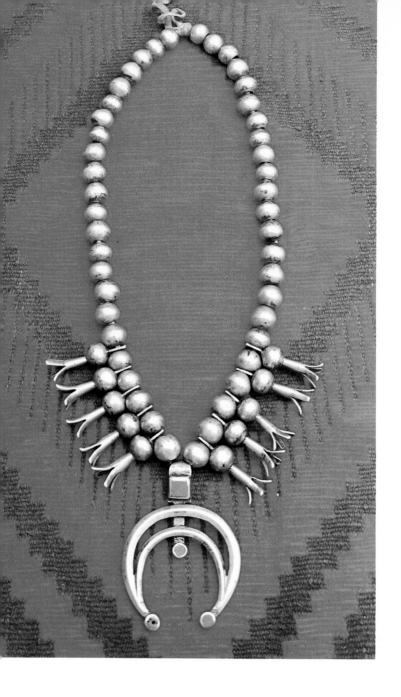

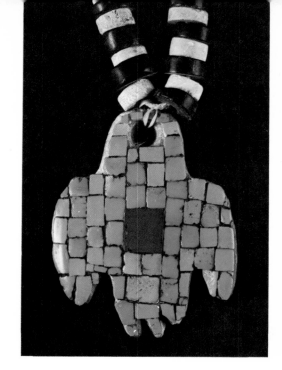

ALTHOUGH THE Spaniard and the Mexican taught the Navaho to work in silver, turquoise jewelry predates the conquest, as the ancient Anasazi pendant (*above*) demonstrates. After the mid-eighteen hundreds, silver-smithing became an established art of the Navahos. The necklace (*above, left*) was fashioned with the popular—but misnamed—squashblossom beads, which are really a Spanish pomegranate design. The *naja*, the crescent-shaped pendant, is also a Spanish emblem. The necklace (*opposite, left*), hung with crucifixes, may have been made for Kit Carson's wife. The concha belts (*below,* and *opposite, below*) are named for the Spanish word for shell. The wrist guard (*opposite, right*) was worn as protection while shooting an arrow.

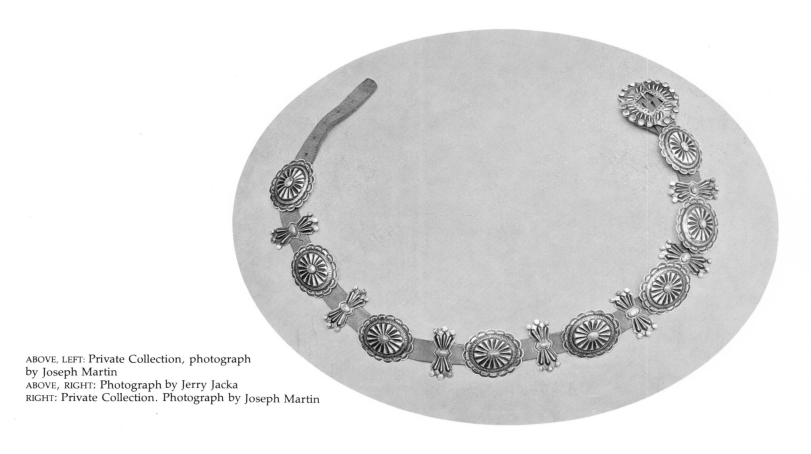

ABOVE, LEFT: Private Collection, photograph by Joseph Martin
ABOVE, RIGHT: Photograph by Jerry Jacka
RIGHT: Private Collection. Photograph by Joseph Martin

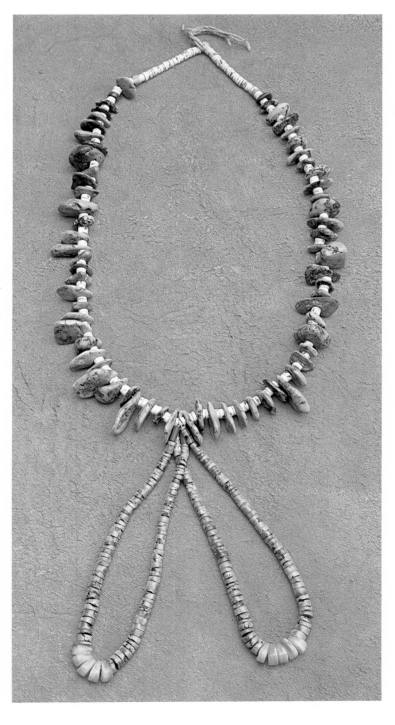

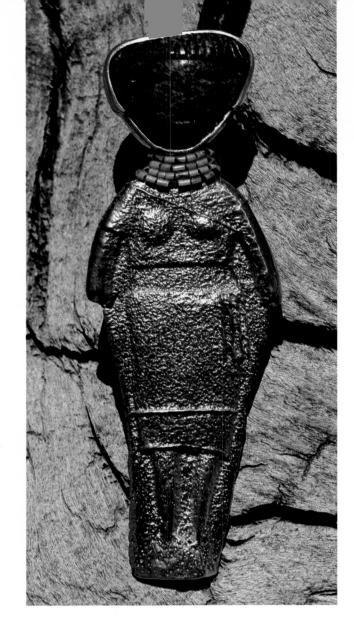

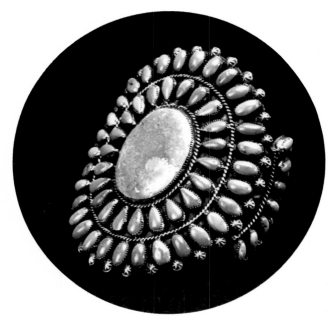

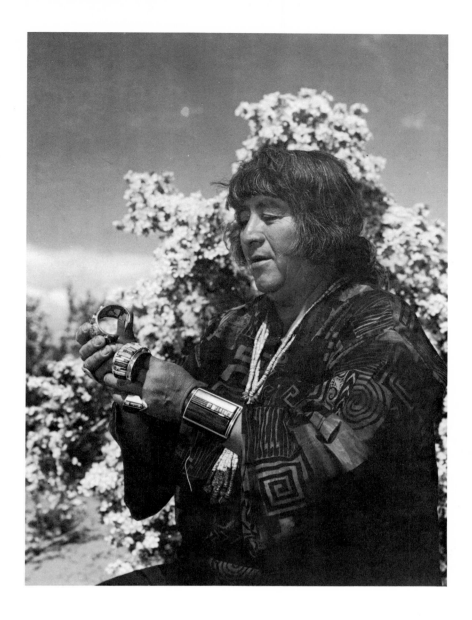

Turquoise for Beauty and Ritual

TURQUOISE HAS BEEN quarried by the Indians of the Southwest for hundreds of years. In ancient times, it was worn by dancers, buried with the dead, and traded for shells with West Coast Indians. In 1539, the Spanish priest Marcos de Niza commented on the vast amount of turquoise worn by Indians: "Some had as many as three or four strings of green stones around their neck; others carried them as ear-pendants or in their noses." This early work, far from being crude or primitive, was executed with the same precision and delicacy that genuine Indian

jewelry displays today. The Navaho necklace (*opposite, left*) dates from 1890; the bracelet of sixty-eight small stones and one big, set in silver (*opposite, right*), is the work of Zuñi jewelers. The contemporary pendant (*opposite, above*) was designed by the Hopi artist Charles Loloma (*above*). Although his reputation is international—he has had shows in Europe as well as in New York—Loloma remains on the Hopi Reservation, teaching young Indian artists, taking time out to cultivate corn and interpreting, as he phrases it, "What I know is beautiful within our past."

OPPOSITE, ABOVE: Photograph by Jerry Jacka
OPPOSITE, LEFT: Private Collection, photograph by Joseph Martin
OPPOSITE, RIGHT: Courtesy, the Museum of the American Indian, Heye
 Foundation, New York, photograph by Carmelo Guadagno
ABOVE: Photograph by Jerry Jacka

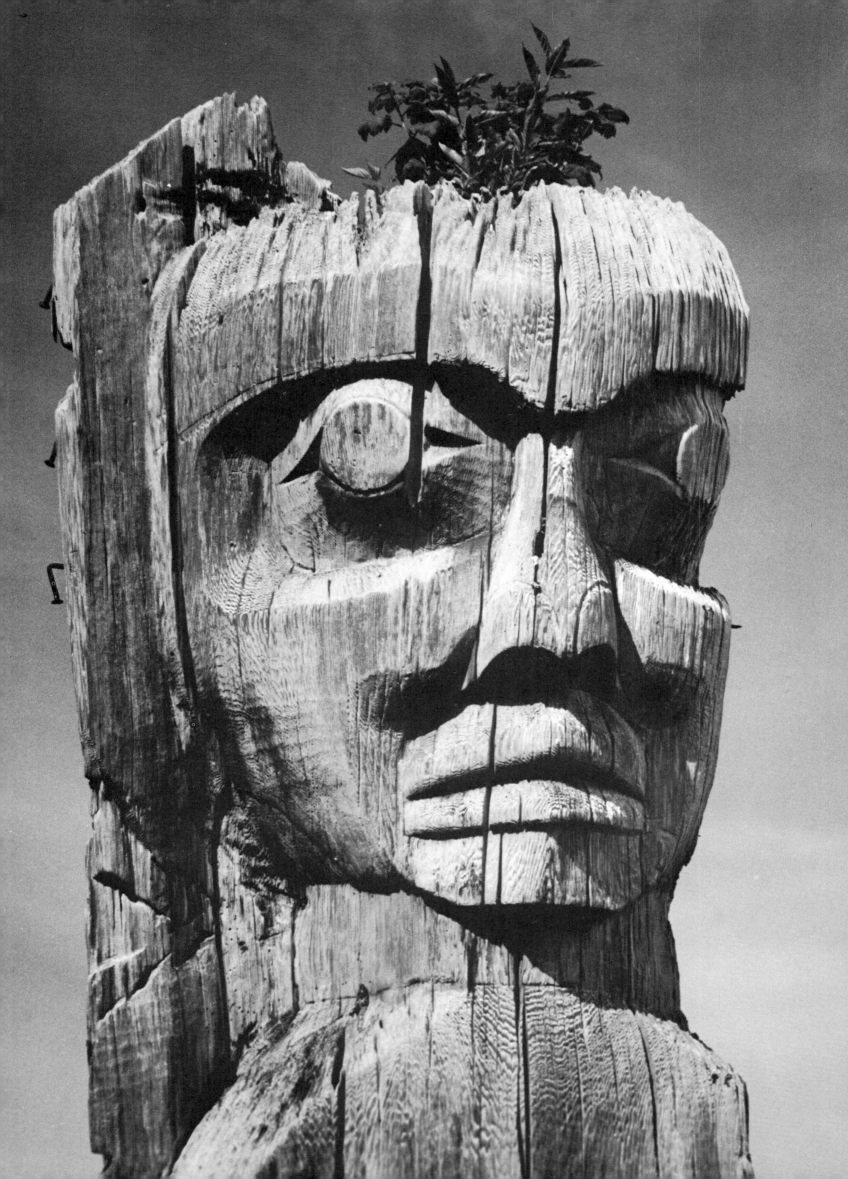

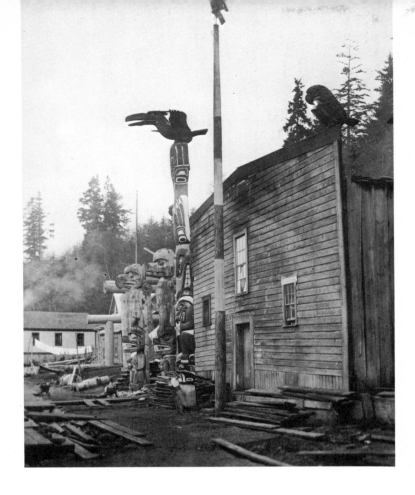

Emblems of a Family's Lineage

THE ESSENCE OF the art of the coastal tribes of the Northwest is expressed in their majestic carved wooden poles (*opposite and right*), which commemorate an individual or honor a family. The isolated poles stand scattered throughout the forest like giant wooden tombstones erected in memory of a man's father or grandfather. The totem poles (*above*) in front of houses belonging to the Kwakuitl tribe of Vancouver Island, British Columbia, serve as emblems of a family's lineage. Like a European coat of arms, they proclaim a clan's social importance.

OPPOSITE AND BELOW: Courtesy, the Amon Carter Museum, ©1971 Amon Carter Museum, photograph by Adelaide de Menil, from *Out of the Silence*
ABOVE: Courtesy, the Museum of the American Indian, Heye Foundation, New York

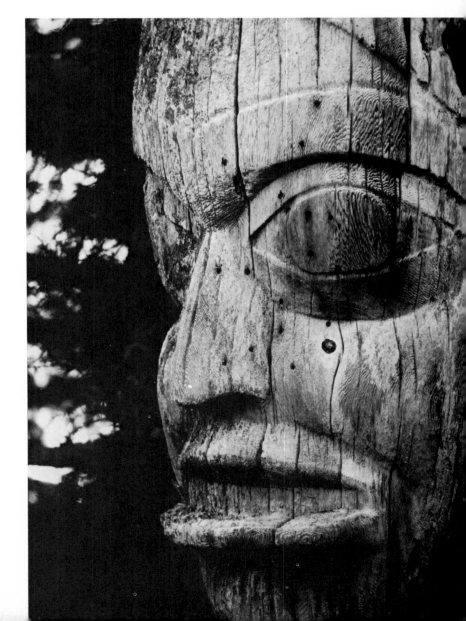

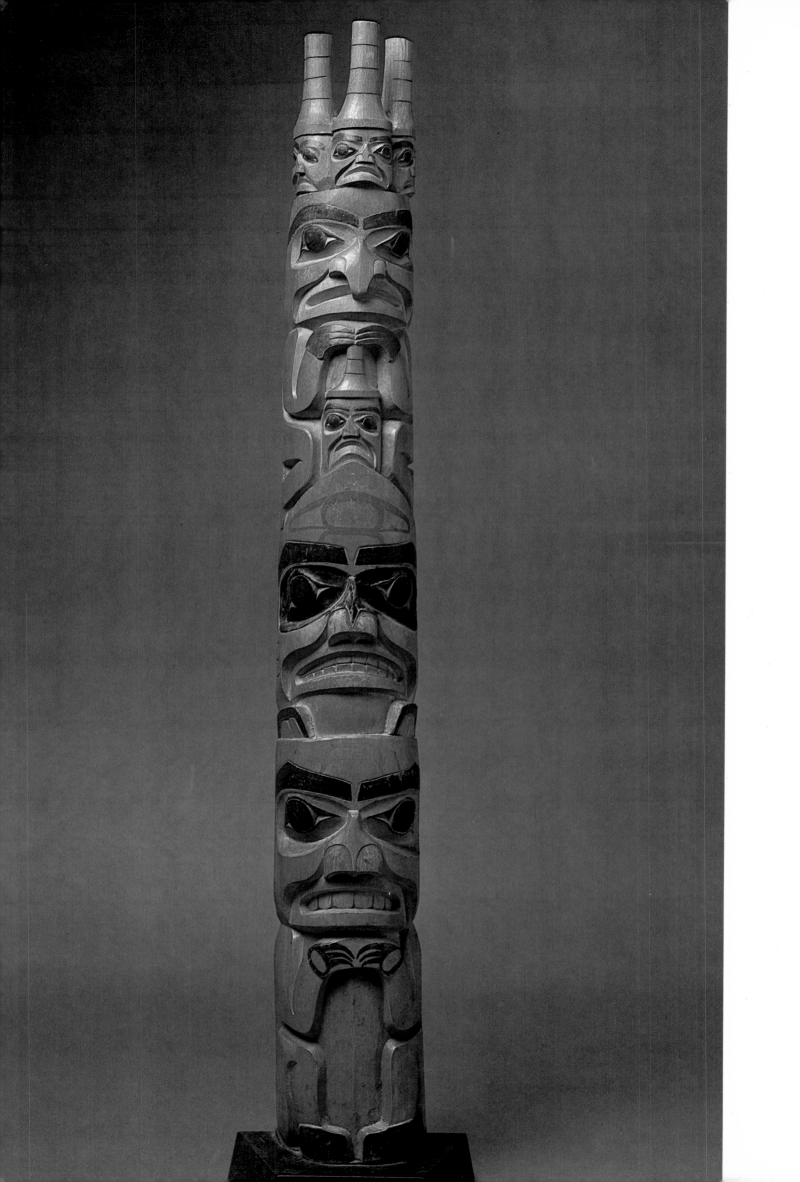

FAMILY AND CLAN relationships were all important among the people of the Northwest. Descent was traced from a mythology based on animals with whom the Indians had a direct bond and an intimate identification. The totem pole (*opposite*) was carved in the 1890s as a model and possibly for sale to curio collectors. From bottom to top, the carvings represent a bear, a killer whale, and a bird of prey; the pole is crowned with three potlatch rings. Each year a family of prestige and wealth validated their standing by a gift-giving potlatch. The carving (*below*) was erected to honor the dead.

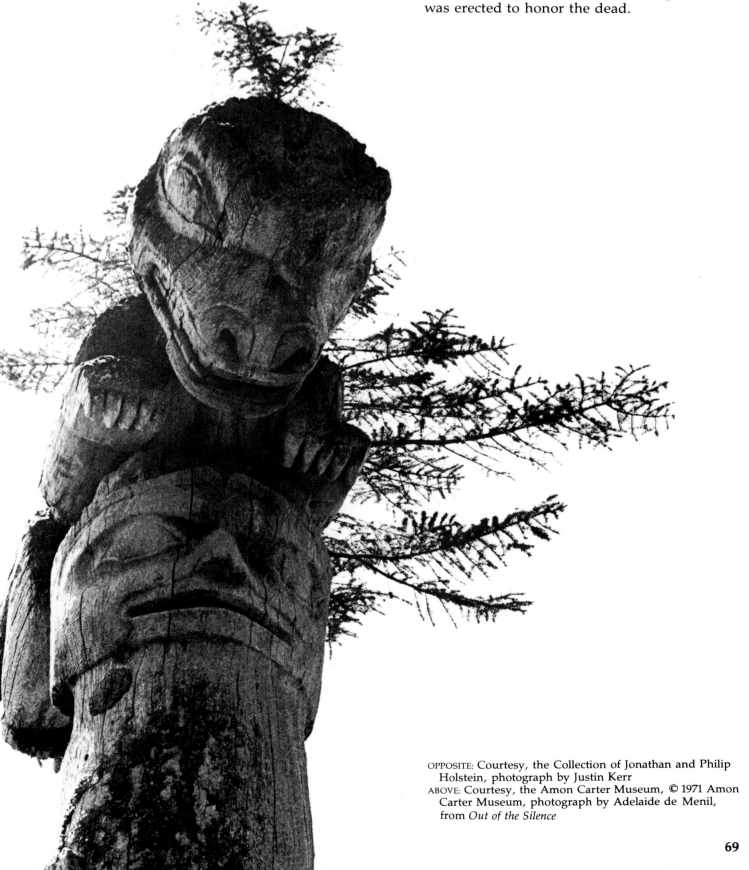

OPPOSITE: Courtesy, the Collection of Jonathan and Philip Holstein, photograph by Justin Kerr
ABOVE: Courtesy, the Amon Carter Museum, © 1971 Amon Carter Museum, photograph by Adelaide de Menil, from *Out of the Silence*

A TRAVELER'S GUIDE

There are many museums and archaeological sites of North American Indian Art throughout the United States and Canada. Listed below by geographic area is a suggested sampling.

Southwest

ARIZONA
Arizona State Museum, Tucson
Canyon de Chelly National Monument, Chinle
Heard Museum, Phoenix
Museum of Northern Arizona, Flagstaff

CALIFORNIA
Lowie Museum of Anthropology, Berkeley
Natural History Museum of Los Angeles County
Southwest Museum, Los Angeles
San Diego Museum of Man

NEW MEXICO
Maxwell Museum of Anthropology, University of
 New Mexico, Albuquerque
Museum of New Mexico, Santa Fe

Northwest

ALASKA
Anchorage Historical and Fine Arts Museum
University of Alaska Museum, Fairbanks
Alaska State Museum, Juneau

CANADA
Museum of Anthropology, University of British
 Columbia, Vancouver
Centennial Museum of Vancouver

OREGON
Oregon Historical Society, Portland
Portland Art Museum

WASHINGTON
Washington State University Anthropology Museum,
 Pullman
Seattle Art Museum
Eastern Washington State Historical Society, Cheney
 Cowles Memorial Museum, Spokane

Great Plains

COLORADO
Denver Art Museum
Denver Museum of Natural History
Mesa Verde National Park

NEBRASKA
Nebraska State Historical Society, Lincoln
University of Nebraska State Museum, Lincoln
Joslyn Art Museum, Omaha

OKLAHOMA
Oklahoma Historical Society, Oklahoma City
Philbrook Art Center, Tulsa
Spiro Mound, Spiro

SOUTH DAKOTA
Robinson Museum, Pierre
Sioux Indian Museum and Crafts Center, Rapid City
W.H. Over Museum, Vermillion

North Central

ILLINOIS
Field Museum of Natural History, Chicago
Illinois State Museum, and Dickson Mounds
 Museum, Springfield

MICHIGAN
University of Michigan Exhibit Museum, Ann Arbor

MISSOURI
University of Missouri, Museum of Anthropology,
 Columbia
Kansas City Museum of History and Science
Nelson Gallery, Atkins Museum, Kansas City

OHIO
Cincinnati Museum of Natural History
Cleveland Museum of Natural History
Serpent Mound State Memorial, Peebles

WISCONSIN
Milwaukee Public Museum

Southeast

ARKANSAS
University of Arkansas Museum, Fayetteville
Museum of Science and History, Little Rock

FLORIDA
Temple Mound Museum and Park, Fort Walton
 Beach
Florida State Museum, Gainesville

GEORGIA
Georgia Department of Natural Resources, Historic
 Sites Section, Atlanta
Etowah Mounds Archaeological Area, Cartersville

LOUISIANA
Louisiana State Exhibit Museum, Shreveport

MISSISSIPPI
State Historical Museum, Jackson

TENNESSEE
McClung Museum, University of Tennessee,
 Knoxville
Cumberland Museum and Science Center, Nashville
Shiloh Mounds, Shiloh National Military Park

Northeast

CANADA
National Museum of Man, Ottawa
Royal Ontario Museum, Toronto

CONNECTICUT
Peabody Museum of Natural History, New Haven

DISTRICT OF COLUMBIA
Smithsonian Institution

MASSACHUSETTS
Peabody Museum, Cambridge Peabody Museum,
 Salem

NEW JERSEY
Newark Museum

NEW YORK
New York State Museum, Albany
American Museum of Natural History, New York
Museum of the American Indian, New York
Rochester Museum and Science Center

PENNSYLVANIA
University Museum, University of Pennsylvania,
 Philadelphia

BIBLIOGRAPHY

Adair, John. *The Navajo and Pueblo Silversmiths.* Norman,
Oklahoma: University of Oklahoma Press, 1944.

Amsden, Charles A. *Navajo Weaving: Its Technic and Its History.*
Glorieta, New Mexico: The Rio Grande Press, 1974; a reprint of
the 1934 edition.

Anderson, John A. and Hamilton, H.J., ed. *The Sioux of the Rosebud:
A History in Pictures.* Norman, Oklahoma: University of
Oklahoma Press, 1971.

Barrow, Susan H. and Grabert, Garland F. *Arts of a Vanished Era.*
Bellingham, Washington: Watcom Museum of History and Art,
1968.

Birket-Smith, Kaj. *The Eskimo.* London: Metheun, 1959.

Boas, Franz. "The Decorative Art of the Indians of the North
Pacific Coast." *American Museum of Natural History Bulletin*,
(1897): 123-176.

Boas, Franz. *Primitive Art.* New York: Dover, 1955, a reprint of the
1927 edition.

Bodmer, Charles. Atlas, vol. 25: *Early Western Travels.* Cleveland:
A.H. Clark Co., 1906.

Catlin, George. *The Manners, Customs, and Condition of the North
American Indians.* 2 vols. London: G. Catlin, 1841.

Chapman, Kenneth M. *The Pottery of Santo Domingo Pueblo; a
Detailed Study of Its Decoration.* Memoirs of the Laboratory of
Anthropology, vol. I. Santa Fe, New Mexico, 1936.

Cincinnati Art Museum. *Art of the First Americans.* Cincinnati,
Ohio: Cincinnati Art Museum, 1976.

Coe, Ralph T. "The Imagination of Primitive Man." *The Nelson
Gallery and Atkins Museum Bulletin* 4, no. I (1962); whole issue.

Coe, Ralph T. *Sacred Circles.* The Nelson Gallery and Atkins
Museum of Fine Arts; Kansas City, Missouri. In cooperation
with the Arts Council of Great Britain with the support of the
British-American Associates, 1977.

Collings, Jerald. "The Yokuts Gambling Tray." *American Indian Art
Magazine* I, no. I (1975): 10-15.

Colton, Harold S. *Hopi Kachina Dolls, with a Key to Their
Identification.* Albuquerque, New Mexico: University of New
Mexico Press, 1959.

Cook, Captain James A. *A Voyage to the Pacific Ocean*, vol. 182. Vol.
3 by Captain James King. London, 1784.

Curtis, Edward S. *The North American Indian*. 30 vols. Cambridge,
Massachusetts: Harvard University Press, 1903-1930; reprinted by
Johnson Reprint, 1970.

Cushing, Frank H. *My Adventures in Zuni.* Palmer Lake, Colorado:
Filter Press, 1967.

Deloria, Vine, Jr. *God Is Red.* New York: Dell Pub. Co., Inc., 1973.

Dockstader, Frederick J. *Indian Art in America.* Greenwich,
Connecticut: New York Graphic Society, 1961.

Douglas, Frederic H. and D'Harnoncourt, Rene. *Indian Art of the
United States.* New York: Musuem of Modern Art, 1941.

Duff, Wilson; Holm, Bill and Reid, Bill. *Arts of the
Raven—Masterworks by the Northwest Coast Indian.* Vancouver,
B.C.: Vancouver, 1967.

Dunn, Dorothy. *American Indian Painting of the Southwest and Plains
Areas.* Albuquerque, New Mexico: University of New Mexico
Press, 1968.

Dutton, Bertha P., ed. *Pocket Handbook: Indians of the Southwest.*
Santa Fe, New Mexico.

Ewers, John C. *The Blackfeet, Raiders on the Northwestern Plains.*
Norman, Oklahoma: University of Oklahoma Press, 1958.

Ewers, John C. *The Horse in Blackfoot Indian Culture.* Bureau of
American Ethnology, Bulletin 159. Washington, D.C.:
Smithsonian Institution Press, 1955; reprinted 1969.

Ewers, John C. *Plains Indians Painting: A Description of Aboriginal
American Art.* Stanford, California: Stanford University Press,
1939.

Fallon, Carol. *The Art of the Indian Basket in North America.*
Lawrence, Kansas: University of Kansas Art Musuem, 1975.

Feder, Norman. *American Indian Art.* New York: Harry N. Abrams,
1971.

Feder, Norman. "American Indian Art Before 1850." *Denver Art
Museum Quarterly* (Summer 1965): whole issue.

Feder, Norman. *Elk Antler Roach Spreaders.* Material Culture
Monographs, no. I. Denver, Colorado: Denver Art Museum,
1968.

Feder, Norman. *North American Indian Painting.* New York:
Museum of Primitive Art, 1967.

Feder, Norman. *Two Hundred Years of North American Indian Art.*
New York: Praeger Publishers in association with the Whitney
Museum of American Art, 1971.

Fewkes, Jesse W. *Hopi Katchinas Drawn by Native Artists*. Glorieta, New Mexico: The Rio Grande Press, Inc., 1969; a reprint of the Bureau of American Ethnology, Annual Report 21, 1903, pp. 3-126.

Flint Institute of Arts. *Art of the Great Lake Indians*. Flint, Michigan: Flint Institute of Arts, 1973.

Frank, Larry and Harlow, Francis. *Historic Pottery of the Pueblo Indians, 1600-1880*. Boston Massachusetts: New York Graphic Society, 1974.

Fred Harvey Fine Arts Collection. Phoenix, Arizona: The Heard Museum, 1976.

Grinnel, George B. *The Fighting Cheyennes*. Norman, Oklahoma: University of Oklahoma Press, 1971; first published by Scribners in 1915.

Harlow, Francis H. *Matte-Paint Pottery of the Tewa, Keres, and Zuni Pueblos*. Santa Fe, New Mexico: Museum of New Mexico, 1973.

Holm, Bill and Reid, William. *Form and Freedom; a Dialogue on Northwest Coast Indian Art*. Houston, Texas: Institute for the Arts, Rice University, 1975.

Holm, Bill. *Northwest Coast Indian Art; An Analysis of Form*. Seattle: University of Washington Press, 1965.

Kane, Paul. *Wanderings of an Artist Among the Indians of North America from Canada to Vancouver's Island and Oregon, through the Hudson's Bay Company's Territory and Back Again*. Toronto: The Radisson Society of Canada, limited, 1925.

Kroeber, Alfred L. *Handbook of the Indians of California*. Bureau of American Ethnology, Bulletin 78. Washington, D.C.; Smithsonian Press, 1925.

Latta, F.F. *Handbook of Yokuts Indians*. Oildale, California: Bear State Books, 1949.

Lister, Robert H. and Lister, Florence C. *The Earl H. Morris Memorial Pottery Collection*. Series in Anthropology, no. 16. Boulder, Colorado: University of Colorado Press, September, 1969.

Mails, Thomas E. *Dog Soldiers, Bear Men and Buffalo Women; A Study of the Societies and Cults of the Plains Indians*. Englewood Cliffs, New Jersey: Prentice-Hall, Inc., 1973.

Mails, Thomas E. *The Mystic Warriors of the Plains*. Garden City, New York: Doubleday and Co., Inc., 1972.

Mails, Thomas E. *The People Called Apache*. Englewood Cliffs, New Jersey: Prentice-Hall, Inc., 1974.

Marriott, Alice. *Maria; The Potter of San Ildefonso*. Norman, Oklahoma: University of Oklahoma Press, 1948.

Mason, Otis Tufton. *Aboriginal American Basketry: Studies in a Textile Art Without Machinery*. Glorieta, New Mexico: The Rio Grande Press, Inc., 1970, a reprint of the Annual Report of the Smithsonian Institution, 1902.

Mason, Otis Tufton. *Indian Basketry*. 2 vols. New York: Doubleday, 1904.

Martin, Paul S.; Quimby, George I.; and Collier, Donald. *Indians Before Columbus: Twenty Thousand Years of North American History Revealed by Archaeology*. Chicago: University of Chicago Press, 1947.

Maxwell Museum of Anthropology. *Seven Families in Pueblo Pottery*. Albuquerque, New Mexico: University of New Mexico, 1974.

Mera, Harry P. *Pueblo Indian Embroidery*. Memoirs of the Laboratory of Anthropology, vol. 4. Santa Fe, New Mexico: University of New Mexico Press, 1943; reprinted by William Gannon, Santa Fe, New Mexico, 1975.

Mera, Harry P. *The 'Rain Bird', A Study in Pueblo Design*. Memoirs of the Laboratory of Anthropology, vol. 2. Santa Fe, New Mexico: University of New Mexico Press, 1937.

Miles, Charles. *Eskimo and Indian Artifacts of North America*. New York: Bonanza Bks., 1963.

Mooney, James. *The Ghost-dance Religion and the Sioux Outbreak of 1890*. Bureau of American Ethnology, Annual Report 14. Washington, D.C.: SMithsonian Institution Press, 1896 (1897); pp. 641-1110.

National Gallery of Art, Washington, D.C. *The Far North; 2000 Years of American Eskimo and Indian Art*. Washington, D.C.: National Gallery of Art, 1973.

Purdy, Carl. *Pomo Indian Baskets and Their Makers*. Ukiah, California: Mendocino County Historical Society, n.d.; a reprint of Pomo Indian Baskets and Their Makers, Los Angeles, C.M. Davis Company Press, 1902.

Ray, Dorothy J. *Eskimo Masks: Art and Ceremony*. Seattle, Washington: University of Washington Press, 1967.

Ritzenthaler, Robert E. *Iroquois False-Face Masks*. Publications in Primitive Art 3. Milwaukee, Wisconsin: Milwaukee Public Museum, 1969.

Schoolcraft, Henry R. *History of the Indian Tribes of the United States: Their Present Condition and Prospects, and a Sketch of Their Ancient Status*. Historical American Indian Press, n.d.; a reprint of the 1857 edition.

Titiev, Mischa. *The Hopi Indians of Old Oraibi: Change and Continuity*. Ann Arbor, Michigan: University of Michigan Press, 1972.

Underhill, Ruth M. *Red Man's America; A History of Indians in the United States*. Rev. ed. Chicago: The University of Chicago Press, 1953, 1971.

Walker Art Center. *American Indian Art: From and Tradition*. Minneapolis, Minnesota: Walker Art Center, 1972.

Waters, Frank. *Book of the Hopi*. New York: The Viking Press, 1963.

Waters, Frank. *Masked Gods . . . Navajo and Pueblo Ceremonialism*. 2nd ed. Chicago: The Swallow Press, 1950.

Weltfish, Gene. *The Origins of Art*. New York: The Bobbs-Merrill Co., Inc., 1953.

Wormington, H.M. *Ancient Man In North America*. Denver, Colorado: Colorado Museum of Natural History, 1957.

ACKNOWLEDGMENTS

Many people gave generously of their time and their knowledge to make this book possible. The editors would especially like to thank the following:

The Museum of the American Indian
 Heye Foundation, New York
U. Vincent Wilcox
Curator of North American
 Archeology and Ethnology;
Carmelo Guadagno and the staff
of the Photographic Services of
the Museum

The University Museum
University of Pennsylvania
Philadelphia, Pennsylvania
Miss Caroline Dosker

The Peabody Museum
Harvard University
Cambridge, Massachusetts
Mr. Dan Jones

Southwest Museum
Los Angeles, California
Mr. Ron Kinsey

The Newark Museum
Newark, New Jersey
Miss Barbara Lipton

Mrs. Helen Hardin
Tesuque, New Mexico

Mr. Jonathan Holstein
New York, New York

Mr. James Economos
New York, New York

Dr. and Mrs. Jerry Solin
New York, New York

Mr. George Terasaki
New York, New York

Mr. M. A. Barnes
Hastings House
Essex, Connecticut

Miss Pamela Forbes McLane
American Indian Art Magazine
Scottsdale, Arizona